W9-AKT-747

SHTETL
LIFE

SHTETL LIFE

The Nathan and Faye Hurvitz Collection

FLORENCE B. HELZEL

with an essay by Steven J. Zipperstein

JUDAH L. MAGNES MUSEUM BERKELEY, CALIFORNIA

This catalog is published on the occasion of the exhibition
Shtetl Life held at the Judah L. Magnes Museum
October 3, 1993–January 31, 1994

Designed, typeset in Granjon with Cochin display, and
 produced by Wilsted & Taylor Publishing Services,
 Oakland, California
Edited by Fronia W. Simpson
Printed and bound by Malloy Lithographing, Inc.

Copyright © 1993 by the Judah L. Magnes Museum.
All rights reserved.
The essay "The Shtetl Revisited" copyright © 1993
by Steven J. Zipperstein. All rights reserved.

Library of Congress Catalog Card Number: 93-077290
ISBN: 0-943376-59-9

Cover: detail from *Marketplace*, Chaim Goldberg, p. 67.

For Larry

Grandson of the shtetl

CONTENTS

FOREWORD

Seymour Fromer

Many of the Jews who migrated to the United States from 1880 to the 1920s traced their origins to the village life of Eastern Europe, and their descendants have been eager to rediscover these roots and to reconstruct this lost culture. The village, or shtetl, was a unique form of community in Poland-Lithuania, Russia, and Austria-Hungary that originally grew out of the distinctive relationship between Jews and the Polish landowners.

Beginning as early as the sixteenth century, Jews were invited to settle in private towns owned by the Polish nobility. There they served the surrounding peasants by selling household goods, clothing, and other necessities and by purchasing agricultural produce. These isolated, far-flung trading centers, primarily inhabited by Jews, developed a warm cohesiveness, with each family occupying a place of its own, if ever so modest, within the community. A few of the shtetls eventually developed into important towns and cities. By the end of the nineteenth century, many of these towns lost their economic function and their inhabitants left for Warsaw, Lodz, and other booming industrial cities.

The distinct Yiddish culture and religious life cycle that developed in the shtetl survives vividly today in folklore and in the visual and performing arts. The prints and drawings in *Shtetl Life* were lovingly assembled by Nathan and Faye Hurvitz over a quarter of a century. They are reflections of the religious, social, and economic pattern of life in the shtetl by artists who either lived there or learned about it from their families. The Hurvitzes formed their collection as a memorial to this life, which was totally obliterated during World War II.

We want to express our special appreciation to the artists represented in this catalog for capturing the spirit of the shtetl for us and for future generations. We are also greatly indebted to the Nathan and Faye Hurvitz family for their gift of these works of art to the Magnes Museum, and to Florence Helzel, curator of prints and drawings, for developing a unique and illuminating exhibition and catalog.

PREFACE

In 1960 Dr. Nathan Hurvitz, a Los Angeles psychologist and counselor, started to collect prints and drawings focusing on shtetl life. Son of Hillel Hurvitz, who was born in Chernigov, Russia, Nathan Hurvitz had roots that were intimately tied to the shtetl. It was his experiences as an infantryman in the United States Army during World War II, however, that brought the lives of East European Jewry to his close attention. His letters to his wife in May 1945 graphically describe the horrors he witnessed when his division took part in the liberation of the concentration camps Dachau and Allach. He wrote about his conversations in Yiddish with prisoners from Hungary, Poland, and Rumania.[1] Deeply moved by their ghastly stories of inhumane treatment, he was determined not to forget them.[2] To honor them and other victims of the Holocaust, the prints and drawings in this catalog were collected and displayed in the Hurvitz home.

Dr. Hurvitz wrote dozens of letters to artists, art dealers, and Jewish service organizations to inquire where art depicting the shtetl could be acquired. Precise in his requests, he insisted that the art actively portray specific aspects of shtetl life. "We prefer works that show people in scenes from their lives," he wrote. "We do not want pictures of a *yid mit a bord*" (Jew with a beard).[3] He was especially delighted with Chaim Goldberg's *Marketplace* and *Parents II*, which show women working alongside men. He also requested that the works be original and returned prints sent to him that were photoreproductions.

For Dr. Hurvitz, having personal contact with the artist was an important part of his collecting philosophy. He and his wife, Faye, visited artists in their homes and studios in the United States and Israel and in turn invited artists to their home. These relationships enriched his collecting program, enabling him to gain special insight into both the artists and their work. He found that he and the artists held similar sentiments; by portraying shtetl life the artists were reminding us and future generations of our heritage and were paying homage to the vanished communities.

After Dr. Hurvitz's death in 1986, the collection remained in his home under the special care of his widow. In 1991 the Hurvitz family donated the prints and drawings to the Magnes Museum. We are grateful to Libbe Madsen, Rabbi Mark Hurvitz, and Jay Hurvitz for their generous gift. I am especially appreciative of Faye Hurvitz's friendship and want to express my thanks to her for gathering together correspondence, pamphlets, and books pertinent to the prints and drawings. She has related fascinating personal accounts of collecting experiences and has been an invaluable sleuth in helping to trace information about the lesser-known artists.

I particularly value this unique collection of art because of the superb opportunity it provided to study a significant part of Jewish history and to learn how fifty-two artists were influenced by shtetl experiences. My research of the lives of those artists unknown to me prompted a chain of letters of inquiry stretching across the United States to Europe and Israel. It was immensely satisfying to find an artist and to discover that he had created a large body of autobiographical imagery of the shtetl.

I want to express my deep thanks to those who played a vital role in the preparation of this catalog and exhibition. I am indebted to Professor Steven J. Zipperstein, director, Program in Jewish Studies, Stanford University, for the major contribution of his article, "The Shtetl Revisited." I am grateful for the valuable suggestions from Deborah Kirshman, fine arts editor, University of California Press, and for the meticulous editing of the manuscript by Fronia W. Simpson. My thanks go also to Natanya Groten, research assistant, Magnes Museum, for her invaluable aid in preparing the artists' biographies; to Zachary M. Baker, head librarian, YIVO Institute for Jewish Research, for his research assistance; and to my translators, Rebecca Beagle, Tova Gazit, Serge Klein, Anita Navon, Alice Prager, and Engel Sluiter. Thanks are also extended to Ben Ailes for photography; to Anita Noennig and her staff for conservation work; to Herbert Singer for matting and framing the prints and drawings; and to the staff of the Magnes Museum for their constant support.

NOTES

1. Correspondence donated to the Western Jewish History Center, Magnes Museum Archives.

2. Dr. Hurvitz's essay, "My Experiences and Observations as a Jew in WWII," based on his letters, shared first prize in a competition sponsored by YIVO Institute for Jewish Research, 1946.

3. Letter to Galerie d'Art Aleph, Paris, December 23, 1981.

INTRODUCTION

Florence B. Helzel

Jewish life in the villages of Eastern Europe before World War II is dramatically described in the Nathan and Faye Hurvitz Collection of Prints and Drawings. A wide range of activity, both secular and spiritual, is illustrated in the seventy-five works. Tradition, religion, family, and community are recurring themes. Scenes of Shabbat, ritual, occupations, personal hardships, and vivid character studies of scholars and rabbis afford a fascinating glimpse into a world that had existed for centuries and was destroyed during World War II.

Most of the fifty-two artists represented were born in a shtetl or born to shtetl parents; they were steeped in Judaic study and ritual. Although their destinies varied greatly, they shared an overriding need to perpetuate the shtetl in their art. But they chose to interpret shtetl life in contrasting ways: either by mirroring a realistic slice of life or by idealizing it. The majority of the art does not concentrate on the prevalent abject poverty, drudgery, and terror-filled pogroms. Instead, the shtetl is remembered for the warmth of familial relationships, the joy in celebrations, and the fervent study of Torah.

Marc Chagall expressed nostalgic feelings about his native Vitebst that are described in vividly colored paintings and prints that are permeated with elements of Hassidic folklore. Flying beasts and roof-perched figures symbolically stress the instability of life during the last years of the czars and also emphasize Chagall's ever-present optimism. From the time he left Russia in 1922, Chagall repeatedly designed nostalgic scenes of his birthplace. He obscured the reality of its shabbiness, poverty, and lack of personal comforts by treating these hardships in a lighthearted way. *House in Vitebst*, an illustration for his autobiography, *My Life*, invites a close look at Chagall's typical style (p. 46). The lopsided house and the outhouse convey a sense of authenticity and also lend amusement. In contrast, the flowerpot in the curtained window and the smoke rising from the brick chimney bring a sense of romanticized order to the setting. "Here is Chagall," the artist proudly inscribes in Russian over the entrance to his home.

Moshe Bernstein held similar sentiments about his native Polish village, Kartuz-Bereza, which are expressed in paintings, drawings, and poetry that act as a memorial to his seventeenth-century shtetl. His poem "Longing to Bereza" emotionally intones affection for his shtetl and sorrow for its tragic fate. The son of parents who perished in the Holocaust and a resident of Israel for the past forty-five years, Bernstein reconstructs memories into poignantly intimate scenes of his childhood, as illustrated in his pen-and-ink drawing of a father and son (p. 38). Bernstein writes that his mission as an artist is "to be the representative and the voice of the innocence, the beauty and the magical appeal of the small Jewish town."[1]

Contrary to this idealized view is the art of Abel Pann. Born in the Latvian shtetl Kreslavka, in 1883, Pann lived and studied in Paris before immigrating to Israel in 1913. While in France, he had the courage to lash out against oppression when he created a series of drawings illustrating atrocities against the Jews in Eastern Europe. The French government suppressed and censored the exhibition of this work for being politically hazardous. (France was allied with Russia at the time.) Pann expresses his heartbreak at the expulsion of the Jews from czarist Ukraine in *The Long Trail* (p. 114). He depicts the victims, guarded by a cossack on horseback, with their backs to the viewer, trudging wearily through the bleak wintery terrain, burdened by age and infirmity. Pann further demonstrates his acute memory in two sets of drawings, *The Tear Jug*, 1917, and *In the Name of the Czar*, 1918.

Russian-born David Labkovsky's art also provides historic documentation of shtetl life. Labkovsky's deep commitment to Judaism and his experience of grim ordeals when exiled to a concentration camp in 1941 prompted his powerful expressionistic imagery of personalities and events. Moving far beyond ordinary observation, he penetrates the soul of his characters, exaggerating facial and physical features. A sorrowful atmosphere pervades his shtetl, overshadowing its frenetic activity. Labkovsky's sparsely etched print in the Hurvitz collection, depicting a water carrier struggling to get his old horse moving, whose load is obviously too heavy, epitomizes the daily struggle for a livelihood among the poor villagers (p. 94).

These few examples highlight the constant shifting between the reality of perception and the nostalgia of memory portrayed in the Hurvitz collection. In both treatments of the shtetl, religion is a constant theme. It pervades all aspects of life

and unifies the culture. Each work of art encourages examination and discussion, posing questions and stimulating future research. A recent poem, "The Stand-Up Shtetl," by Elaine Terranova, sensitively captures the contrasts in shtetl life.[2]

> *It is nearly Rosh Hashonah. The blacksmith*
> *is forging good luck for all this new year.*
> *Likewise, the feather plucker, with his goose down,*
> *is laying the groundwork for a year's*
> *innocent sleep. "From your mouth to God's ear,"*
> *the townspeople greet one another,*
> *although some will wander, with open collars,*
> *with exposed throats, into the path*
> *of thundering Cossacks. You may ask, Is this*
> *where it leads, all the whispering to God?*

NOTES

1. *M. Bernstein*, exh. cat. (Tel Aviv: Chemerinsky Art Gallery, 1965).

2. Elaine Terranova, "The Stand-Up Shtetl," 1992. First-prize winner, Sixth Annual Anna Davidson Rosenberg Award for Poems on the Jewish Experience, sponsored by the Magnes Museum, 1992.

THE SHTETL REVISITED

Steven J. Zipperstein

To the memory of my aunt Sylvia Teplinsky, 1905–1940,
a Yiddish poet born in Lahishen, near Pinsk

S*htetl* is one of a small cluster of terms—along with *cossack* or *pogrom*—that in
the contemporary Jewish lexicon seem to provide a remarkably transparent way of
evoking the East European Jewish past. Unlike the others, shtetl reminds one
(mostly, perhaps not entirely) of good things: of the comfortable, reassuring joys of
family, piety, community, unencumbered identity—in short, of a supposedly seam-
less way of life left behind in the rush for the bounty of social mobility in a new,
deracinated, fiercely individualistic world. Even less heartening features of the
shtetl, for instance its undeniable poverty or intolerance toward internal dissent,
appear in retrospect as having positive implications in their encouragement of com-
munal and familial cohesiveness. Few terms evoke quite so vividly for Jews the
wages of modernity, what was abandoned to achieve what they now have.

The dictionary definition for shtetl would have it that it is the diminutive for the
Yiddish word *shtot*, or city, a small town of the sort—many of them little more
than primitive market depots for outlying agricultural regions—that existed well
into the twentieth century in Russia and Galicia. In Russia, the bulk of these so-
called *shtetlech* were in the regions of Lithuania, Poland, and Ukraine, in lands
annexed by the Russian empire with the disintegration of Poland-Lithuania in the
late eighteenth century. But what, in fact, is it that distinguishes a big, or middle-
sized, town from one that is small? (One recalls the self-conscious obfuscations in
Sholom Aleichem's autobiography *From the Fair* in a chapter entitled "The Town"
and subtitled "the little town . . .": "Like all biographers, I really should cite the
name of the city and the date of our hero's birth. But frankly this doesn't interest
me. Little Kasrilevke, or Voronko, interests me more, for no other village in the
world more impressed itself on Sholem's memory. . . .")[1]

The lines between city, town, townlet, and village in Eastern Europe seem, and
often were, blurred, a product of frequently arbitrary distinctions between *gorod*,

© 1993 by Steven J. Zipperstein. All rights reserved.

posad, and *mestechko*, the three types of urban settlements in czarist Russia. It is the last, a variation on the Polish, that most closely resembled what came to be known as a shtetl—a sort of lesser city with commercial rights but without the urban charters that marked a *gorod*. Indeed, in nineteenth-century Russia it came to be assumed that to the extent to which a *mestechko* was distinct from a rural settlement it was in the presence of Jews. As the distinguished Russian social geographer N. A. Miliutin stated bluntly, "It is possible . . . to consider as a city or a mestechko all those settlements in which exists a separate Jewish community."[2]

In their origins in the sixteenth and seventeenth centuries these towns were products of the eastward push of Jews into sparsely populated lands allocated by the crown to Polish magnates beyond the urbanized western portions of the kingdom. Until then most Jews in older, western Poland lived in big towns such as Cracow, Poznań, and Lvov, where the pressures of local nobility and burghers to limit Jewish residence or commerce provided added impetus for a migration to the raw small towns and villages of the east in need of managerial skill, markets, and capital. Many of the new towns—called private towns—were owned by magnates, and these urban enclaves represented, along with the villages of nobles, ways for their owners to acquire wealth on what were, quite simply, extensions of a ramified agrarian economy. In such settings Jews served magnates by helping them enjoy the benefits of their monopoly rights (over the sale of liquor, the use of mills, etc.), by acting as factors in the sale of agricultural products, poultry, field crops, or cattle—in short, by providing a midlevel, urban expertise (rarely were estates administered by Jews) in the remotest reaches of the Polish kingdom. By the late eighteenth century, most Jews who lived in towns in the East European region congregated in the smaller towns of the eastern portions of the kingdom, in places with fewer than five hundred Jews and often with as few as one hundred. Rarely in Ukraine, more often in Lithuania, Jews were in the majority; but even when they were not, sections of the towns—the central area surrounding the market was often one of these—were predominantly Jewish, with outlying neighborhoods dominated by non-Jews.[3]

True, much of Central and even West European Jewry lived well into the nineteenth century in small, rather than large, towns, and even in villages: in postrevolutionary France (as the historian Paula Hyman has noted) the majority of its 40,000 Jews could be found in some 180 mostly tiny localities in the Alsatian countryside where their lives could not have been more distinct from the tiny, politicized minority in Paris or, for that matter, their acculturated Sephardic brethren

elsewhere in France. These Ashkenazic Jews, much like their counterparts in Eastern Europe, spoke Yiddish, were religiously observant, and obeyed a conservative small-town rabbinate. And most German Jews, too, lived similar lives, and in comparable provincial settings, until the second half of the nineteenth century.[4]

Rarely in the West, though, was there the density that remained a trademark of urban and semiurban Jewish life in the East, where the Jewish population increased from some 450,000 in 1650 to 750,000 in 1800 and to 6,000,000 in the Russian empire by 1900. The communal autonomy enjoyed by the Jews of Eastern Europe—facilitated by their wide geographic dispersion and also (in the last century or two of Polish rule) the diminishing powers of the king—was unique in the Jewish world in its complexity and breadth. And, of course, while most Jews elsewhere in Europe in the nineteenth century (with the exception of those in Galicia) eventually moved to big cities, entered the middle class, discarded Yiddish for the vernacular, and minimized or rejected aspects of Judaism considered sacrosanct in the East, the Jews of Russia and Poland—though they too became increasingly urbanized—retained a mostly traditional religious, social, and economic profile into the twentieth century.

It was the shtetl that came to encapsulate for many the difference between Jewish life in the East and West: between small and big towns, between lives that were static and in flux, between the security of tradition and the uncertainty of the new. Often what this meant was that the actual locale of small-town Jewish life—its economy, demography, cultural and social mores—receded into the background. What took precedence was the small town as metaphor, a construct born out of the conflicting ideologies that made the Jewish street into contested territory in the last decades of Romanov rule prior to the 1917 Russian Revolution. The ideological battles themselves were conducted mostly in cities; by the second half of the nineteenth century, the bulk of the area's Jews relocated to the larger cities of the Pale of Settlement and Poland. And it was precisely this urbanization, as we shall see, that was crucial in transforming the shtetl into a locus of imagined Jewish authenticity, the natural setting for the new Yiddish novel, and a prime object of East European Jewish nostalgia.

This is apparent even in the memoirs of the sober Russian-Jewish historian Simon Dubnow, whose ten-volume history of the Jews remains a standard text and who wrote the well-known three-volume *History of the Jews in Russia and Poland*. A severe, keenly principled, utilitarian, non-Zionist but nationalist liberal, he tells in his Russian-language memoirs that his first published article, "Letter from

Mstislavl," was a denunciation of the obscurantism of his native Belorussian shtetl. Above all, the article denounced the traditional education system of the heder— rather standard fare in the modernist attacks on traditional Jewish life—an institution that, as Dubnow stated elsewhere, was a "prison for children. A great crime is committed there: A massacre of innocents, the murder of the spirit and flesh. . . . There the monstrous Babylonian wisdom is violently hammered into their infant heads."[5]

This is how he characterized his shtetl as a twenty-year-old positivist firebrand: as hopelessly backward, as oppressive (known as a freethinker, he was hounded by children on its streets), as a place from which to flee, which is precisely what he did. At his first opportunity he left for larger cities and eventually settled in Odessa, along with much of the rest of the self-conscious Jewish intelligentsia of the time, most of whom had also escaped small towns like Mstislavl.

Once he returns for a series of prolonged visits (never, of course, does he contemplate living here again, since by now he is a writer of some reputation in the small but vibrant world of Russian-Jewish journalism) he begins to see Mstislavl through different eyes. It is a place wholly different from "gloomy Petersburg" where he lives at the time; here his "wife met [him] on the porch in a shining halo of sunlight and led [him] into two spotlessly clean rooms. . . . It was a bright time in [their] life." The once-vast chasm separating his modernist aspirations from the rabbinic world of his saintly grandfather, a leading figure of Mstislavl, now appears to lessen considerably:

From the autumn of 1884, the following picture could be seen in the quiet provincial town: On two parallel streets grandfather and grandson sat in their booklined studies. One cultivated the wisdom of the Talmud and the rabbis and transmitted it to his listeners, the other plunged with equal zeal into the new wisdom of the age and had his own distant, but more numerous audience. . . . Both lived like the Nazarenes, obedient to strict vows, each with his own understanding of life, intellectually different, ethically identical.[6]

Crucial in this regard is Dubnow's sense that his own audience is immeasurably more numerous, if less visible in remote Mstislavl, than his grandfather's, a man who represents a small-town world fast disappearing. Indeed, Dubnow can afford to dwell on the virtues of shtetl life now that it is passing into history. Buttressed by his positivist commitments, which instruct him that traditionalist forces are on the wane, influenced by a newfound Jewish nationalism that makes him ever more

attentive to the wellsprings of the Jewish spirit (as he defines them), his attitude toward Mstislavl is warm, tolerant, and strangely nostalgic.

It is much the same tone that we find in the Yiddish literature of the time. It is here that we encounter the most concrete and influential representations of the shtetl. In part, these satisfied the needs of writers eager to locate a coherent "social space"—"an interdependent cluster of time, space, characters, ideas, and style which motivate each other and also represent some conception of a society and a language," as Benjamin Harshav writes in *The Meaning of Yiddish*.

The search for an original fictional world that would be both removed from naturalistic descriptions and sufficiently representative of the new problems of the time, including a self-critical perception of Jewish existence in history, was not easy for a Jewish writer. . . . Hence, the tendency to ground the fictional world in the specifically Jewish small town, raised to symbolic proportions.[7]

The shtetl provided writers with their own private territory, with a typology of characters, with what Harshav calls "Yiddishland," where "the beliefs, prejudices, proverbs, primitive jokes, and naive 'wisdom' of its characters . . . were still untouched by the all-flattening Enlightenment and could still be believable."[8]

"Yiddishland" was imagined, then, in the larger cities of Russia and Poland by writers aware that they—with their Europeanized clothes, their citified manners, and their modernized beliefs—could but look at their native shtetlech from the outside, from a vantage point akin to that of Isaac Leib Peretz, the statistician in "Impressions of a Journey through the Tomaszow Region" who encounters in the shtetl marketplace Jews who exclaim when he first appears in town: "'Can the Shepherd above really need helpers like him?'"[9] And as was true for Dubnow, this newfound perspective on the shtetl was born out of a sense that it was increasingly a thing of the past: its once-austere, self-sufficient culture was under siege as the small town was threatened by economic forces, especially the spread of the railroad in the Russian Pale of Settlement linking once-remote, economically self-sufficient semiurban enclaves with the larger world. This meant the decline of traditional Jewish occupations (like trade and personal services) in favor of craft and industrial employment. It also meant that once-sacrosanct customs were challenged as previously cloistered places were transformed into busy points of transit. And those that were not were rendered irrelevant as market towns in a Russia where the distribution of goods could now be centralized in the larger cities. "From the day the rail tracks were laid through this [small Lithuanian] town," writes Israel Weisbrem, the

author of the 1888 Hebrew novel *Ben ha-zemanim*, "its residents . . . began to wander throughout the entire world and to travel to faraway cities, whose ways and customs and characteristics they learned and brought back with them."[10]

The upheavals of East European Jewish life over the next several decades— pogromist violence, mass migration, revolution, civil war, and, under the Soviets, officially sanctioned class struggle on the Jewish street—intensified, of course, such images of shtetl life. (The Soviet Yiddish poet Izi Kharik wrote in 1924: "I gaze through thirsty eyes / And further—further I stretch my neck: / There were little shtetlech spread about here / Quietly resting . . . / And I myself helped to wreck them / And I sent them all up in smoke / Now I hear the stars atrembling / I am drawn away and carried on high.")[11] The horrors of the Holocaust, with its destruction of whatever remnants of small-town Jewish life had survived the repressions and poverty of the interwar years in Soviet Russia or Poland, stamped such images with permanence. The events of this century served to reify images of shtetl culture already in place in the last years of the nineteenth century. These are the images that have come to represent in contemporary Jewish memory the texture of East European Jewish life—often culled from the literary world of Mendele Mocher Seforim, Sholom Aleichem, and Peretz. It is these that have proven immeasurably more influential than historical literature; indeed, much of what has been written on shtetl life for English-speaking readers understands such literary representation as history.

Clearly this is the case for the most influential of all such work, Mark Zborowski and Elizabeth Herzog's 1952 anthropological study *Life Is with People*. The tale of this book's curious genesis must still be written. Supervised by the seminal anthropologists of their generation, Ruth Benedict and Margaret Mead (who wrote the introduction), sponsored under the institutional rubric the Columbia University Research in Contemporary Cultures, it was written mostly by the then-celebrated Zborowski who was discovered soon after its publication to be a Stalinist agent who had infiltrated Trotskyist and other anti-Bolshevik circles in Paris and perhaps elsewhere. Indeed, it is generally assumed by specialists in the history of left-wing politics that he played a role in the killing of Trotsky's son Lev Sedov. In view of the book's impact, in particular its influence on the making of *Fiddler on the Roof* (the Broadway play's producers admitted that *Life Is with People* was a primary inspiration), it should further serve to caution us as to how images of the shtetl tell

more about those who promote them than they do about the history of the East European small town.[12]

Here, for instance, the marketplace, the heart of the Jewish small-town economy—around which the houses of the town's richer Jews were typically built, where one's livelihood was made, and where interaction with non-Jews was most common—is marginalized in a book that opens with chapters on the Sabbath: "'My shtetl,'" writes Zborowski, "means my community, and community means the Jewish community. Traditionally, the human rather than the physical environment has always been given primary importance."[13] The struggle for economic sustenance is reviewed fleetingly in one brief chapter sandwiched between expositions on status formation and weddings. The exterior of shtetl homes is all but irrelevant to Jews, argues the book, because of their unworldliness; their world is placid, stable, static, without serious class or social conflict, even without antagonism between Christian and Jew.

Did Zborowski really believe he captured the texture of East European Jewish small-town life? Even an otherwise laudatory review in *Commentary* that appeared late in 1952 scored the book for its unwillingness to tackle the tensions and antagonisms of the shtetl. He overlooked, insisted the reviewer, "the arrogance and dictatorial tendencies of the wealthy over against the grumbling envy and grinding misery of the poor."[14] Or did he, for reasons of convenience or self-conscious dissimulation, simply sustain a literary tradition already well in place and which, despite the author's disgrace not long after the book's publication, continued to mollify, to patronize Jewish needs rather than to illuminate the past?

"The townlet of my birth, Motol, stood—and perhaps still stands—on the banks of a little river in the great marsh area which occupies much of the province of Minsk. . . ."[15] So begins Chaim Weizmann's autobiography, *Trial and Error*, written soon after he became Israel's first president and published in 1949. Was Motol so inaccessible that Weizmann, a man of considerable power and influence, could not ascertain whether it still existed? Or was that beside the point? By the time of his writing, the shtetl had been transmuted into metaphor even for those, like Weizmann, who could vividly recall the lives they had led in such places. But the places themselves came to represent something else: a common childhood irretrievably lost, a hearth eradicated, good times when families were whole, when faith was steady, when God favored his people.

1. Sholom Aleichem, *Funem yarid*, in *Aleh verk fun Sholem Aleichem*, vol. 15 (New York: Sholem-Aleykhem Folksfund, 1925), p. 19. For an abridged translation see *From the Fair: The Autobiography of Sholom Aleichem*, trans. and ed. Curt Leviant (New York: Viking, 1985).

2. Quoted in Thomas Stanley Fedor, *Patterns of Urban Growth in the Russian Empire during the Nineteenth Century* (Chicago: University of Chicago Press, 1975), p. 13.

3. For historical background see M. J. Rosman's excellent monograph *The Lords' Jews: Magnate-Jewish Relations in the Polish-Lithuanian Commonwealth during the Eighteenth Century* (Cambridge, Mass.: Harvard University Press for the Center for Jewish Studies, 1990).

4. Paula E. Hyman, "The Social Contexts of Assimilation: Village Jews and City Jews in Alsace," in *Assimilation and Community: The Jews in Nineteenth-Century Europe*, ed. Jonathan Frankel and Steven Zipperstein (Cambridge: Cambridge University Press, 1992), pp. 110–29.

5. See Sophie Dubnov-Erlich, *The Life and Work of S. M. Dubnov: Diaspora Nationalism and Jewish History*, trans. Judith Vowles (Bloomington: Indiana University Press, 1991), p. 77.

6. Ibid., p. 78.

7. Benjamin Harshav, *The Meaning of Yiddish* (Berkeley: University of California Press, 1990), p. 153.

8. Ibid. On the literary representation of the shtetl see Dan Miron's pioneering *Der imazsh fun shtetl* (Tel Aviv: Farlag Y. L. Perets, 1981). Also see Ruth Gay, "Inventing the Shtetl," *The American Scholar* 53 (Summer 1984): 329–49.

9. Peretz's "Impressions of a Journey through the Tomaszow Region" is reprinted in English translation in Ruth R. Wisse, ed., *The I. L. Peretz Reader* (New York: Schocken Books, 1990). See esp. p. 21.

10. Israel Weisbrem, *Ben ha-zemanim* (Warsaw, 1888), chap. 2. Quoted in Steven J. Zipperstein, *The Jews of Odessa: A Cultural History, 1794–1881* (Stanford, Calif.: Stanford University Press, 1985), pp. 16–17.

11. See Zvi Y. Gitelman, *Jewish Nationality and Soviet Politics: The Jewish Sections of the CPSU, 1917–1930* (Princeton, N.J.: Princeton University Press, 1972), p. 232.

12. For a description of Mark Zborowski's espionage activities see Elisabeth K. Poretsky, *Our Own People: A Memoir of "Ignace Reiss" and His Friends* (Ann Arbor: University of Michigan Press, 1969). Also see David Dallin, "Mark Zborowski, Soviet Agent," *The New Leader*, March 26, 1956, pp. 15–16.

13. Mark Zborowski and Elizabeth Herzog, *Life Is with People: The Culture of the Shtetl* (New York: Schocken Books, 1952), p. 22.

14. *Commentary Magazine*, December 1952.

15. Chaim Weizmann, *Trial and Error* (New York: Harper & Row, 1949), p. 3.

CATALOG

Catalog entries are arranged alphabetically by artist's last name. Dimensions for the entire sheet are given in centimeters, followed by inches, with height preceding width. "A.P." designates artist's proof. An asterisk indicates that a discussion of book illustrations by a given artist can be found in Levy and Helzel, *The Jewish Illustrated Book* (see Bibliography).

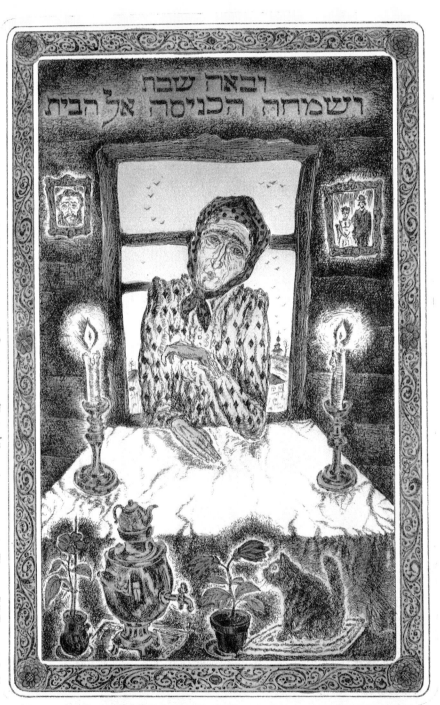

ובאה שבת
ושמחה הכניסה אל הבית

17/110 יבגני אברהם E.Abershaus 78.

EUGENE ABESHAUS

b. 1939

Painter, architect. Born in Leningrad, USSR. Graduated from the Mukhin Higher Industrial Institute of Art, Leningrad, 1973. Founder and leader of the Aleph Group of Jewish Artists, not sanctioned by the Soviet government. First exhibition of Aleph Group at his studio in Leningrad, 1975. A documentary photo panel of this exhibition under the title *Twelve from the Soviet Underground* traveled in Europe and the United States, 1976–78, including the Magnes Museum, 1976. To Israel, 1977. Works in Artists' Village, Ein-Hod.

And Shabbat Came, Bringing Happiness to the Home, 1978
Hand-colored etching, 17/110, on ivory Fabriano paper
48.3 × 35.2 cm (19 × 13⅞ in.)
Signed and dated lower right: *E. Abeshaus 78.*;
signed in Hebrew lower left; title in Hebrew upper center
91.57.1

This etching was printed and vividly hand colored by Abeshaus in Ein-Hod Artists' Village print shop, Israel. It displays the strong folk influence on his art and was included in a major solo exhibition of Abeshaus's graphics and paintings sponsored by the Association of Creative Intelligentsia, "World of Culture," Baltic branch in St. Petersburg, August 1992. Vladimir Gronsky and Enna Romanovsky stated in their introduction to the catalog of this exhibition: "His variations of the 'mestechko' [Ukrainian shtetl] series express an urgent and almost maniacal need of a man, forcibly deprived of his kith and kin, to find his roots and to stretch a binding thread from the characters of Sholom-Aleykhem through the worlds of Chagall and his own memory" (p. 4). After fifteen years in Israel and with his art recognized internationally, Abeshaus returned to his birthplace to be rediscovered by a new generation in Russia.

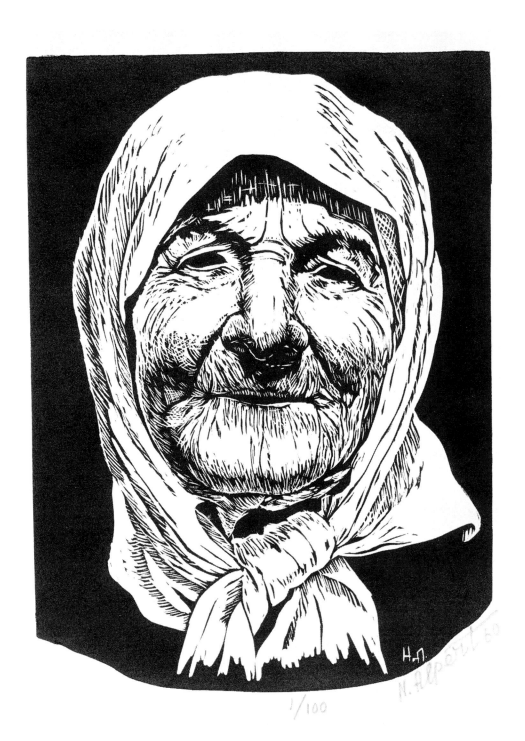

1/100 N. Alport 80

NACHUM ALPERT

1913–1989

Painter, printmaker. Born in Slonim, Poland. Studied at the art school in Vilna, Lithuania; graduated 1934. First exhibition in Vilna, 1937. Studied art in Yerevan (Armenian Republic, USSR), 1943–47. To New York, 1978. From 1950 exhibited regularly in major Russian cities. From 1965 to 1985 had twelve solo exhibitions in Eastern Europe, Tel Aviv, and New York.

Die Altichke
(The Old Woman), 1960
Linocut on ivory
wove paper, 1/100
55.7 × 40.8 cm (21⅞ × 16 in.)
Signed and dated lower right:
N. Alpert 60
91.57.2

Alpert's exhibition at the Workman's Circle, New York, in 1968, depicted the life of Jews in the Eastern European shtetls. The artist worked mainly with watercolors, oil on paper, and black-and-white linoleum engravings such as *Die Altichke*.

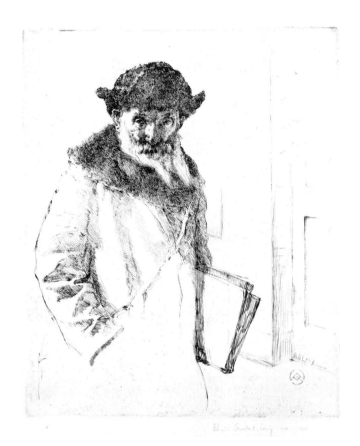

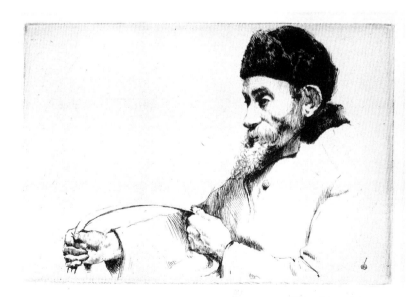

WILLIAM AUERBACH-LEVY

1889–1964

Painter, etcher, caricaturist. Born in Brest-Litovsk, Russia. To New York, 1894. Studied at National Academy of Design, New York; Académie Julian, Paris. Taught at National Academy of Design, Educational Alliance Art School, and Roerich Museum, all New York. Won the Isaac N. Maynard Portrait Prize at the National Academy of Design, 1925. Caricaturist for the *World* (New York). Published *Is That Me? A Book about Caricature*, 1947. Exhibition, Educational Alliance Art School Retrospective Art Exhibit, 1963.

Untitled
(Elderly Man with Book), 1915
Etching on ivory wove paper
38.8 × 30.5 cm (15¼ × 12 in.)
Signed and dated lower right:
*William Auerbach-Levy
imp. 1915*; signed and dated
in plate lower right
91.57.47

Auerbach-Levy was known for his caricatures of political, theatrical, and artistic personalities, but he also specialized in serious portraiture and figure studies. This etching represents a Son of Torah—a learned man, a scholar.

Untitled
(Portrait of a Drayman)
Etching on ivory wove paper
21.8 × 28.5 cm (8⅝ × 11¼ in.)
Signed lower right:
William Auerbach-Levy
91.57.48

In the shtetl there is less need of porters than in the city, but the coachman or driver, the 'baleyoleh,' is a well-known and indispensable figure. Using a carriage or a wagon in summer and a sleigh in winter, he takes people from one shtetl to the next" (Zborowski and Herzog, *Life Is with People*, p. 243).

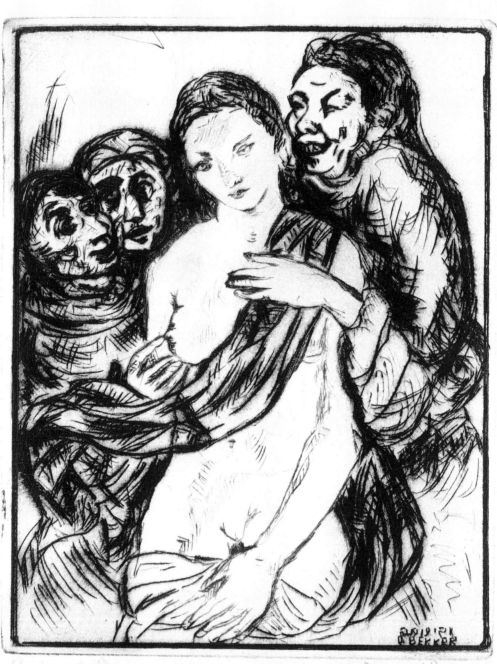

Ritual Bath

David Berger
David July =/=

DAVID BEKKER

1897–1956

Painter, printmaker, sculptor. Born in Vilna, Lithuania. Studied at Antokolsky Art School, Vilna; Bezalel Academy of Arts and Design with Boris Schatz and Abel Pann, Jerusalem; Denver Academy of Art, Colorado. To Chicago, 1920. Published *Myths and Moods*, a collection of linocuts, in 1932. Won the Martin Cahn Prize in the fifty-third annual exhibition of American Painting and Sculpture at the Art Institute of Chicago.

Ritual Bath
Drypoint on ivory Rives paper
24.3 × 21.3 cm (9⅝ × 8⅜ in.)
Signed lower right: *David Bekker* and in Hebrew; signed in plate lower right: *D. Bekker* and in Hebrew; inscribed lower left: *Ritual Bath*
91.57.3

This print appears in the portfolio *Two Worlds*, published in 1936 by M. Ceshinsky, Chicago (see Helzel, *Narrative Imagery*, p. 65). The portfolio comprises ten drypoints focusing on age-old traditions and folklore of the ghetto. The bath (mikveh) is a pool for ritual purification.

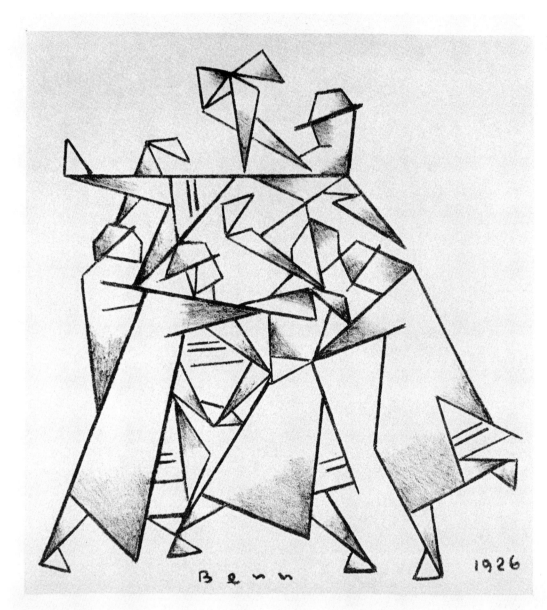

Benn 1926

BENN [BENTZION RABINOVICH]

1905–1989

Painter, printmaker, book illustrator, set and costume designer, sculptor. Born in Białystok, Poland, to an architect father who taught him Bible stories, which remained with him and influenced much of his art. Admitted to the Union of Professional Artists, Białystok, 1929. To Paris, 1930. Interned in Beaune-la-Rolande during German occupation. Member of Jewish School of Paris. Received Chevalier of the Legion of Honor, 1974. In 1975, on his seventieth birthday, the celebration Jubilé de Benn, in Paris, honored him for fifty years of painting. Illustrated *Song of Songs*, *Psalms of David*, and an edition of the *Haggada*.

Untitled
(Dancing Figures), 1926
Lithograph on olive
wove paper, 19/25
34.4 × 27.8 cm (13½ × 10⅞ in.)
Signed lower right and in plate
lower center: *Benn*; dated
in plate lower right: *1926*
91.57.4

These figures, rendered in cubist style, are in sharp contrast to Tully Filmus's more representational dancers (see p. 54), yet the intense spirit and energy of the Hassidic dancers are demonstrated in both.

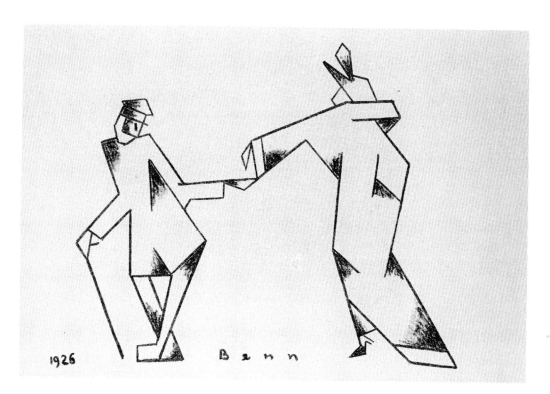

1926 Benn

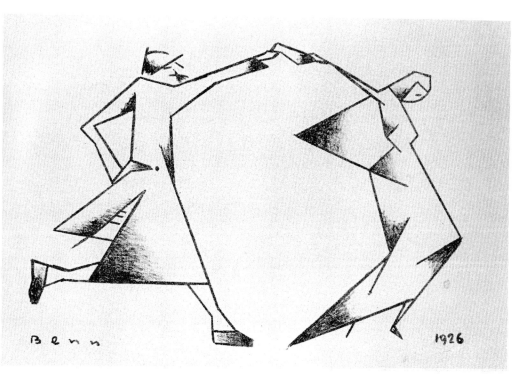

Benn 1926

Untitled
(Man and Woman), 1926
Lithograph on olive
wove paper, 25/25
28 × 31.8 cm (11 × 12½ in.)
Signed lower right and in plate
lower center: *Benn*; dated
in plate lower left: *1926*
91.57.5

With an economy of line and detail, Benn suggests that this well-dressed couple is probably en route to a festive event.

Untitled
(Dancing Couple), 1926
Lithograph on olive
wove paper, 10/25
27.8 × 32.3 cm (11 × 12¾ in.)
Signed lower right and in
plate lower left: *Benn*; dated
in plate lower right: *1926*
91.57.6

Benn illustrates the way men and women danced together in the shtetl. The partners hold the corners of a handkerchief between them, as physical contact with single women was forbidden among the orthodox.

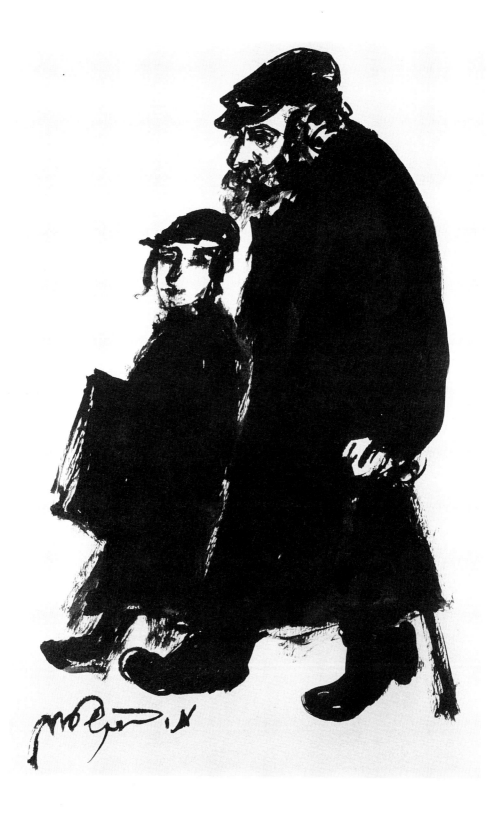

MOSHE BERNSTEIN

b. 1920

Painter, graphic artist, poet. Born in Kartuz-Bereza, Poland, to a Hassidic family. Studied at Vilna Art Academy, Lithuania; graduated 1939. Escaped to the USSR during World War II and lived there until 1947. To Israel, 1948, through Cyprus; participated in the Israel War of Independence in 1948. Perpetuates images of the shtetl in his art.

Untitled
(Father and Son)
Black ink on ivory wove paper
34.9 × 24.9 cm (13¾ × 9¾ in.)
Signed in Hebrew lower left
91.57.7

As a Jewish artist, in my ceaseless search for the deepest expression of the human soul, I have bound myself to the theme of the small Jewish town (the shtetl). I have committed myself to its way of life, with all its rich shades, to which I once belonged as flesh of its flesh" (*M. Bernstein*, exh. cat. [Tel Aviv: Chemerinsky Art Gallery, 1965]).

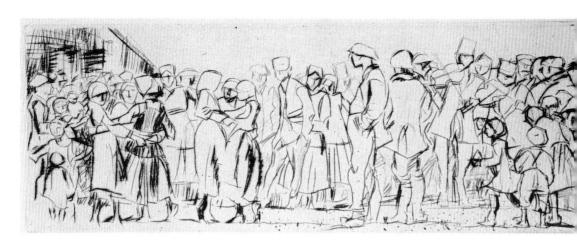

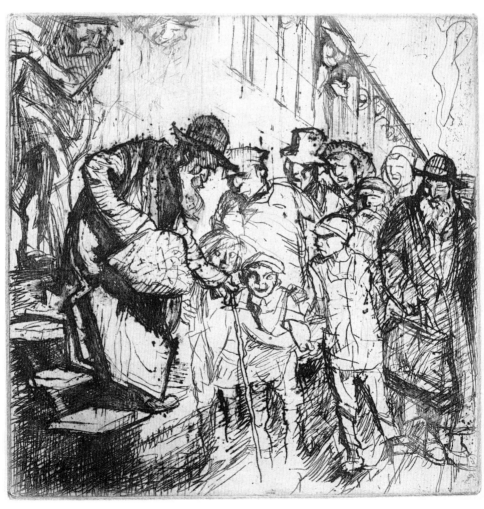

SIR FRANK BRANGWYN

1867–1956

Painter, printmaker, draftsman, book illustrator, metal-
worker, potter, designer of decorative panels, stained
glass, and tapestry. Born in Bruges, Belgium. Studied
with William Morris at the School of Art, London.
Chevalier of the Legion of Honor, 1901. Elected to the
Royal Academy, London, 1919. Knighted, 1941. Became
the first living artist to be honored with a retrospective
at the Royal Academy, 1952.

Untitled
(The Jews of Hounfalou), 1931
Etching on buff wove paper
28 × 39 cm (11 × 15⅜ in.)
91.57.9

This etching appears in chapter 1 of *L'Ombre de la croix*
(The Shadow of the Cross) by Jérome and Jean Tharaud
(Paris: Editions Lapina, 1931) and illustrates the line,
"All the Jews of Hounfalou, men, women, children,
were gathered before the door of Reb Amram Trébitz"
(p. 37). Brangwyn made seventy-three etchings to illus-
trate this novel. Originally published in 1917, it describes
shtetl life in the Carpathian Mountains of Hungary and
was one of a series of books the Tharaud brothers,
French novelists and essayists, wrote to explain Judaism
and traditional Jewish life to the French.

Untitled
(Arrival)
Etching on Japan Ancien
paper, first state, 2/10
39.1 × 28.2 cm (15⅜ × 11⅛ in.)
91.57.8

The spontaneous and energetic lines of Brangwyn's typi-
cal etching style are demonstrated in this print. Brang-
wyn's work was much admired for its technical skill and
dramatic effects.

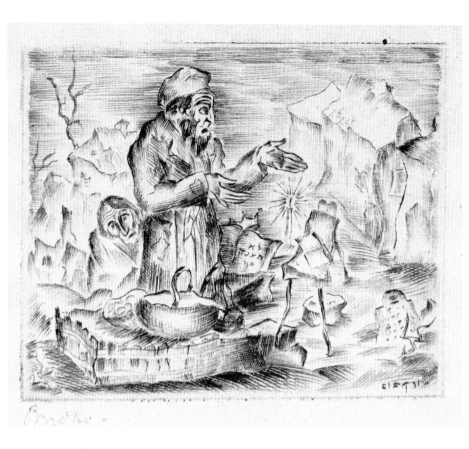

Brief

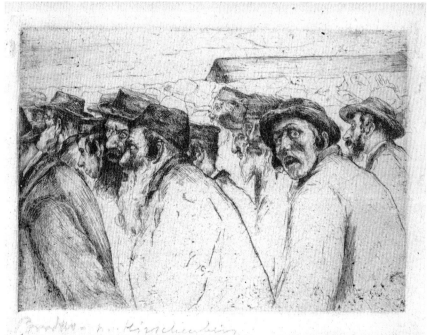

Brief - Verschickung

JOSEPH BUDKO

1888–1941

Primarily a graphic artist; made etchings, woodcuts, lithographs. Born in Plonsk, Poland, son of a tailor. Studied at Academy of Fine Arts, Vilna, and with Hermann Struck in Berlin, 1910. To Israel, 1933. Director of the Bezalel Academy of Arts and Design, 1935–40.

Untitled
(The Ninth Commandment)
Etching on buff wove paper
16.3 × 12.2 cm (6⅜ × 4¾ in.)
Signed lower left: *Budko*;
signed on tombstone lower
right in Yiddish, reversed
91.57.10

Placed in a shtetl setting, Budko's etching emphasizes the Ninth Commandment. Written on the tablet in Hebrew is "You shall not bear false witness against your neighbor."

Untitled
(Pogrom)
Etching on buff wove paper
17.7 × 22.9 cm (7 × 9 in.)
Signed lower left: *Budko*;
inscribed lower left:
n. Hirschenberg
91.57.11

Budko took his subject from the painting *The Black Banner*, 1905, by the Polish artist Samuel Hirschenberg. This is a detail from that painting. *The Black Banner* is also known as *The Funeral of the Zaddik* and suggests the impact of pogroms on Jewish life.

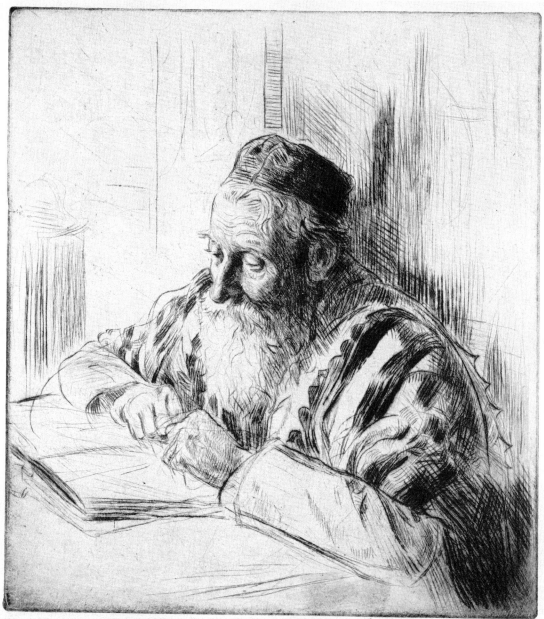

Rabbinical Scholar Samuel Cahan

SAMUEL GEORGE CAHAN

1886–1974

Painter, illustrator, portraitist, printmaker. Born in Russia. To the United States, 1886. Grew up on the Lower East Side, New York. Studied at National Academy of Design, New York. First prize for etching, 1907, National Academy of Design. Staff artist for the *World* (New York) for thirty-two years. Illustrations appeared in the *Saturday Evening Post*, *Collier's*, *Argosy*, and the *New York Times*. Painted portraits of famous subjects such as President Herbert Hoover, Margaret Sanger, Albert Einstein, and the official portrait of Woodrow Wilson, used for his presidential campaign.

Rabbinical Scholar
Drypoint on buff wove paper
31.8 × 27.7 cm (12½ × 10⅞ in.)
Signed lower right: *Samuel Cahan*; inscribed lower left: *Rabbinical Scholar*
91.57.12

Cahan produced a series of etchings on Jewish themes, using an impoverished elderly Jew, David Lehman, as his model. Cahan was impressed with the fine shape of Lehman's head and the expression on his face. A 1930 article from the *World* (New York) states: "Once in the studio, a skull cap and a prayer shawl miraculously transformed an old clothes man into a latter-day Moses."

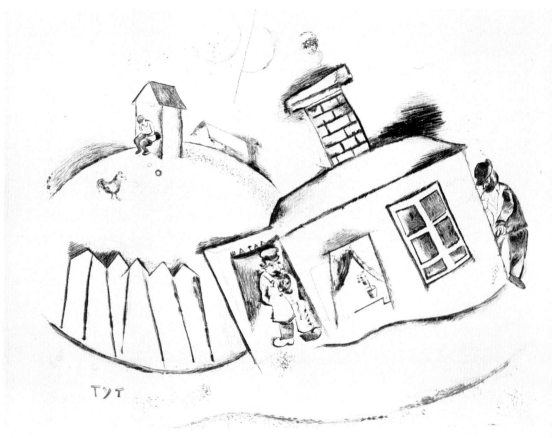

MARC CHAGALL

1887–1985

Painter, graphic artist, book illustrator,* watercolorist, ceramicist, designer of theater sets and costumes, stained-glass windows, and murals. Born in Vitebst, Russia. Gained prominence as commissar for art, organizing art schools, museums, exhibitions; director of Vitebst Academy of Art; designer for Chamber State Jewish Theater. Settled in Paris, 1923. One of the most internationally acclaimed Jewish artists of the twentieth century.

House in Vitebst, 1922
Etching and drypoint on
ivory wove paper, 81/110
35.5 × 44.6 cm (14 × 17½ in.)
Signed lower left:
Marc Chagall
91.57.13

Chagall learned the rudiments of etching from Hermann Struck while living in Berlin in 1922. Commissioned by the Berlin publisher Paul Cassirer, Chagall made a series of etchings and drypoints to illustrate his autobiography, *My Life*. They were the first prints Chagall ever made. Twenty etchings without text were published in 1923 in a limited edition of 110. During his stay in Berlin, Chagall also made lithographs in Joseph Budko's studio. Chagall's autobiography was published with illustrations in Paris by Librairie Stock in 1931.

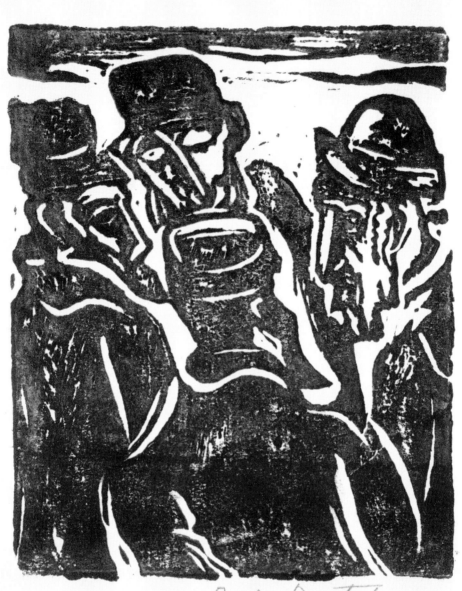

Boris Deutsch 1944

BORIS DEUTSCH

1892–1978

Painter, printmaker, draftsman. Born in Krasnagorka, Lithuania. Studied at Polytechnic School, Riga, Latvia, 1905; School of Applied Arts, Berlin, 1912. To California, 1919. Taught at Otis Art Institute, Los Angeles, 1944–50. *The Legacy of Boris Deutsch*, a centennial exhibition, was held at the Magnes Museum May 24– September 20, 1992.

This highly prolific artist, known primarily for his paintings, also produced hundreds of prints, watercolors, and drawings, and executed government-sponsored mural projects.

Untitled
(Four Men in Conversation),
1944
Woodcut on ivory laid paper
18.6 × 13.8 cm (7⅜ × 5⅜ in.)
Signed and dated lower right:
Boris Deutsch 1944
91.57.14

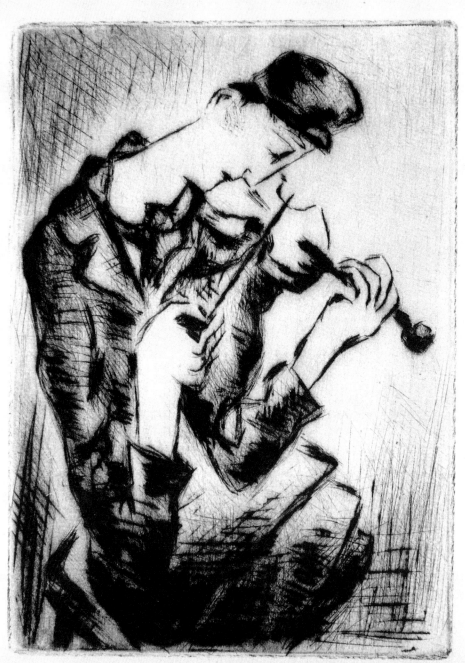

Village Fiddler Boris Deutsch

Village Fiddler, 1944
Drypoint on cream wove paper
19.2 × 12 cm (7⅝ × 4¾ in.)
Signed lower right:
Boris Deutsch; inscribed
lower left: *Village Fiddler*
91.57.15

Deutsch recalls his roots for this depiction of a village fiddler, a prevalent theme among shtetl artists. The fiddle, the most popular musical instrument in the shtetl, was an essential component of klezmer music.

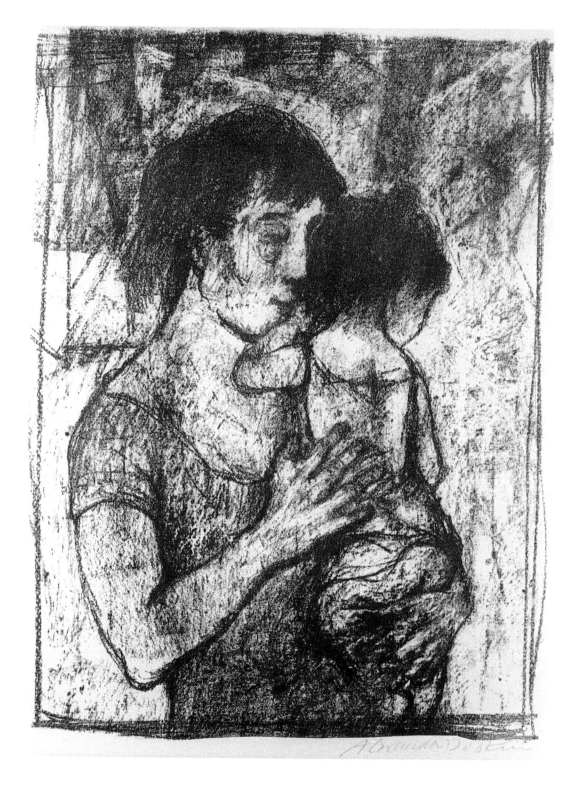

ALEXANDER DOBKIN

1908–1975

Printmaker, book illustrator, graphic artist, author, lecturer, teacher. Born in Italy. To the United States, 1913. B.S., City College of New York; M.A., Columbia University; Arts Students League, all New York. Taught at New Art School, New York, 1937–41; City College of New York. Art director, Educational Alliance Art School, New York, 1934–55; director, 1955–75. Illustrated a wide range of classics, including *A Child's Garden of Verses*. Won many awards, including Pennell Purchase Award of the Library of Congress, 1949 and 1955.

Motherhood
Lithograph on
ivory wove paper
40.7 × 31.5 cm (16 × 12⅜ in.)
Signed lower right:
Alexander Dobkin
91.57.16

Dobkin made this lithograph in Paris for the Association of American Artists. Here fine draftsmanship is combined with his love for humanity. In a 1961 Association of American Artists catalog, Dobkin wrote, "This subject matter is timeless and universal. . . . Women and children appear in my work constantly. I consider this lithograph to be one of my best and strongest variations on this theme."

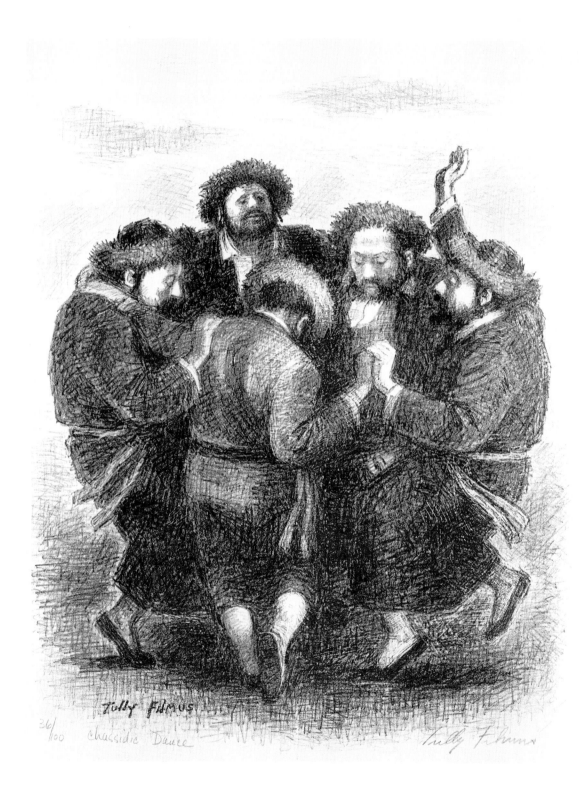

36/100 Chassidic Dance

TULLY FILMUS

b. 1908

Painter, portraitist, lecturer, teacher. Born in Otiek, Bessarabia, Russia. Son of an artist and grandson of a muralist. To the United States, 1913. Studied at Pennsylvania Academy of the Fine Arts; New York University; Art Students League, New York; Barnes Foundation, Merion, Pennsylvania; in Paris with André Lhote; worked independently in Florence, Rome, Munich, 1928–30. Taught at Cooper Union, New York; American Artists School, 1938–47. Worked in W.P.A. Art exhibited widely in museums and galleries in the United States and Israel. *Tully Filmus: Selected Drawings* published by the Jewish Publication Society of America, 1971.

Chassidic Dance, ca. 1960
Lithograph on ivory
wove paper, 36/100
53 × 45.1 cm (20⅞ × 17¾ in.)
Signed lower right and in
plate lower left: *Tully Filmus*;
inscribed lower left:
Chassidic Dance
91.57.17

Deeply affected by the Holocaust, Filmus sought to rediscover his Jewish roots. His art since World War II has focused mainly on his Hassidic past. Here he expresses the emotion and fervor of Hassidic dancing. Filmus feels that his talent was inherited. His father designed ornaments, especially Torah mantles, for the temple, and his great-grandfather was a muralist, painting frescoes in Russian churches (from an interview in the *Forward*, June 22, 1984).

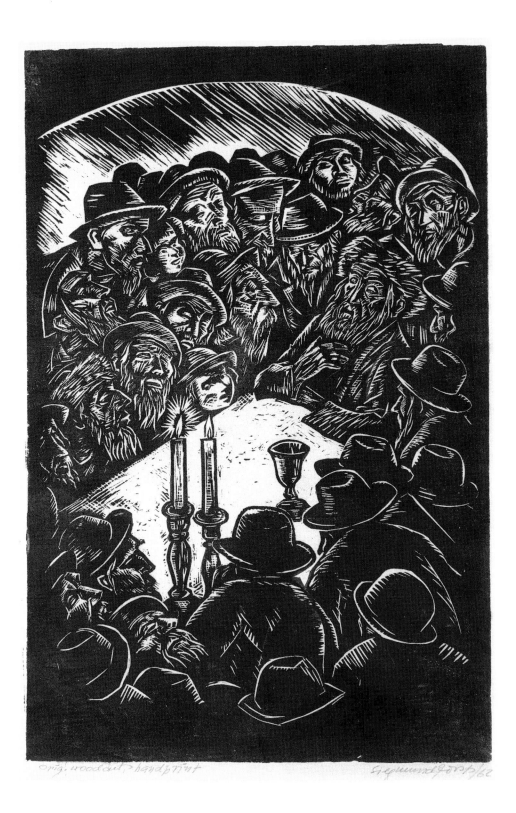

orig. woodcut, handprint

SIEGMUND FORST

b. 1904

Graphic artist, designer of book jackets. Born in
Vienna. Studied at Vienna School of Graphic Arts;
State Academy of Fine Arts; Mattersdorfer Yeshiva, all
Vienna. Student of Rudolph von Larisch, a pioneer in
the design of ornamental lettering. Gave private lessons
in *gemara* (rabbinic discussions) because Jewish schools
were forced to close, 1938. To the United States, 1938.
Designed and illustrated new editions of the five Megil-
loth and Passover Haggadah; introduced ornamental
Hebrew lettering into America. Wrote articles on Jewish
philosophy.

A Rebbe's Tish
(A Rabbi's Table), 1962
Hand-printed woodcut
on ivory wove paper
46×28.6 cm (18⅛×11¼ in.)
Signed and dated lower right:
Siegmund Forst/62;
inscribed lower left:
orig. woodcut, handprinted
91.57.18

I had occasion to observe Hassidic life in Vienna during
and after World War I when that city was crowded
with Polish Jews, refugees from the Russian invasion of
Galitzia. I also visited Poland some years later where I
became interested and even fascinated by Hassidic life"
(Forst to Nathan Hurvitz, August 11, 1982).

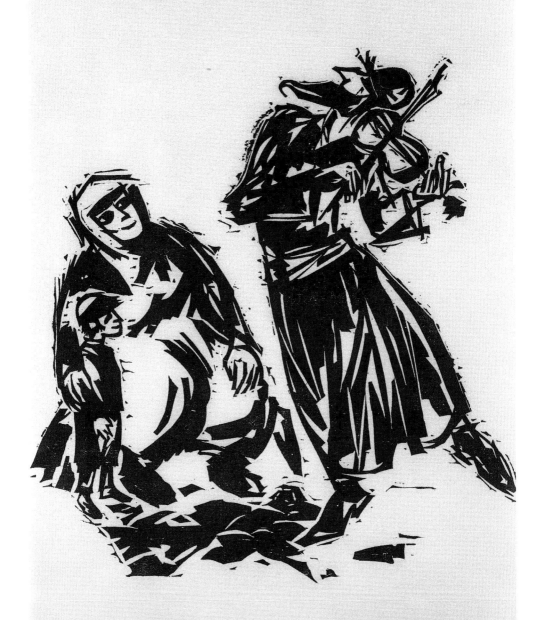

100/100 BEFORE I FORGET Monica GARCHIK, imp.

MORTON GARCHIK

b. 1929

Printmaker, painter, book illustrator, sculptor. Born in Brooklyn, New York. Grandparents born in Russian shtetl. Studied with Max Beckmann in the Art School of the Brooklyn Museum, 1948; with Gabor Peterdi at the School of Visual Arts, New York; received B.A. in art history, Goddard College, Vermont. Won Purchase Prize award from Olivet College, Michigan, 1965. Author of *Art Fundamentals* and *Creative Visual Thinking*. Illustrations appear in Avon paperback edition of Isaac Bashevis Singer's *Gimpel the Fool*.

Before I Forget, ca. 1960
Woodcut on ivory
wove paper, 100/100
36×25 cm (14¼×9⅞ in.)
Signed lower right: *Morton Garchik, imp.*; inscribed
lower left: *Before I Forget*
91.57.19

Garchik designed this woodcut for the book jacket of *Before I Forget*, by Meyer Sluyser, published in New York and London by T. Yoseloff, ca. 1960. The artist also did a two-color version of this print, under the title *Joyous Songs*. In 1967 he made a series of illustrations, *Chasidic Tales Retold*, published as a children's workbook.

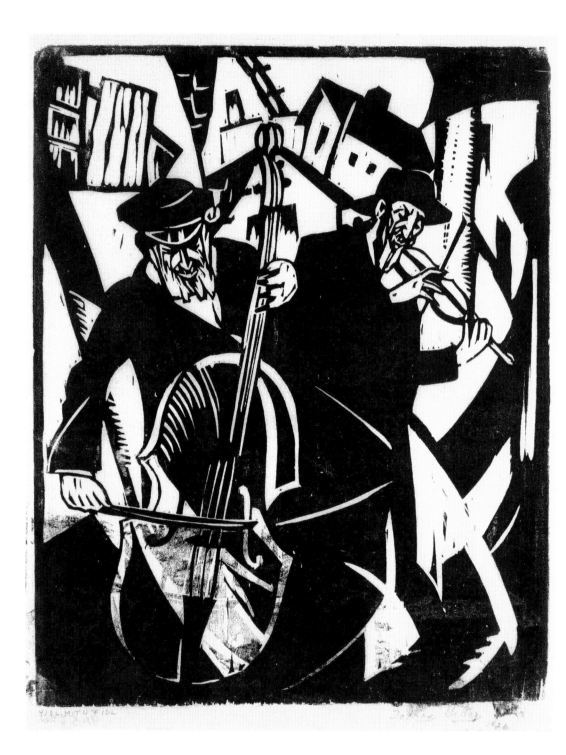

YIDL MITH FIDL

TODROS GELLER

1889–1949

Painter, printmaker, teacher, designer of bookplates and stained-glass windows. Born in Vinnitsa, Ukraine. Because of pogroms, family fled Russia to Canada, 1906; to the United States, 1915. Studied in Odessa; Canada; with Leopold Seyffert, George Bellows, and John Norton at the Art Institute of Chicago. Illustrated some two dozen Jewish books.* Best known for paintings and wood engravings.

Yidl mitn Fidl
(Jew with a Fiddle), 1926
Woodcut on ivory wove paper
32.5 × 25.5 cm (12¾ × 10 in.)
Signed and dated lower right:
Todros Geller 1926; inscribed
lower left: *Yidl Mitn Fidl*
91.57.20

This print was one of the most popular of Geller's works. The wooden houses and the exuberance of the klezmer musicians reflect the spirit of the shtetl. Passing their skills down from father to son, the klezmer were itinerant musicians traveling from shtetl to shtetl playing at weddings, festivals, and country fairs. Their music combined Hebraic themes and native folk melodies.

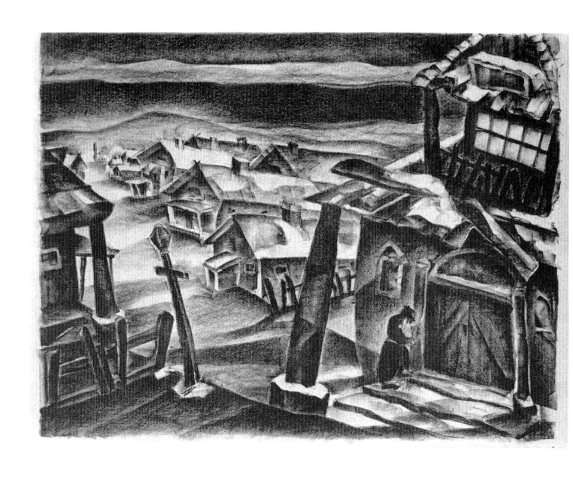

Shul Gass
(Synagogue Street), 1939
Lithograph on olive laid paper
38 × 47.4 cm (15 × 18⅝ in.)
Signed and dated lower right:
Todros Geller '39;
inscribed lower left: *Shul Gass*
91.57.21

The orthodox synagogues as centers of learning and prayer were a dominant force in shtetl life. Geller places the synagogue among the typical ramshackle houses of the shtetl.

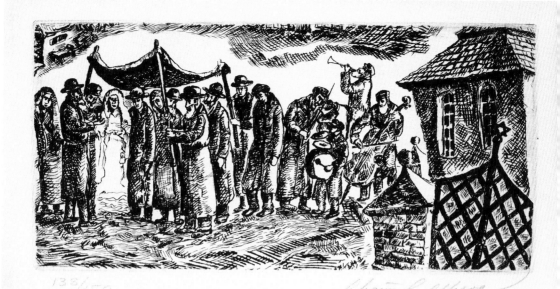

138/150

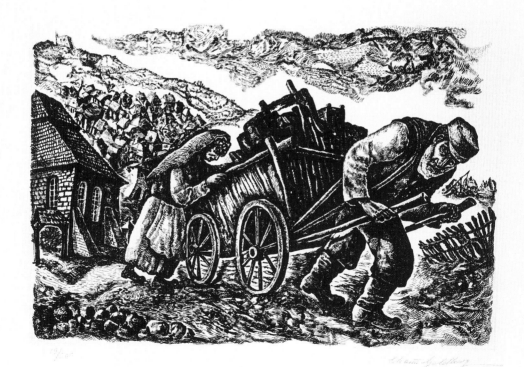

CHAIM GOLDBERG

b. 1917

Painter, watercolorist, sculptor, printmaker, set designer. Born in Kazimierz, Poland. Studied with Zbigniev Pronaszko at the Art High School, Cracow, 1931; with Tadeusz Pruszkovski, dean of the National Academy of Fine Arts, Warsaw, 1934. To the USSR, 1939. Won Silver Medal from the Artists Guild, Novosibirsk, 1944. Studied at Ecole Nationale des Beaux-Arts, Paris, 1947. To Israel, 1955; to the United States, 1967. To Houston, Texas, 1974. Executed large-scale wood carvings and sculptures in colored concrete. Created large series of oil paintings depicting his shtetl, 1987.

Wedding, 1970
Etching on ivory wove paper,
138/150
23.9 × 37 cm (9⅜ × 14½ in.)
Signed lower right:
Chaim Goldberg
91.57.23

The bride and groom stand under a chuppah, symbol of the Jewish home, while the klezmer musicians proclaim the milestone event.

Moving Day, 1970
Etching and engraving on
ivory wove paper, 19/200
38.2 × 56.5 cm (15 × 22¼ in.)
Signed lower right:
Chaim Goldberg
91.57.25

Household possessions fit into one cart for these poor shtetl inhabitants. Goldberg also made a watercolor version of this theme.

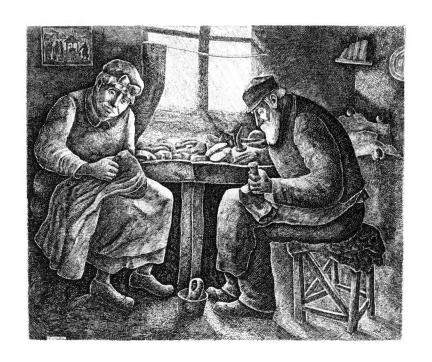

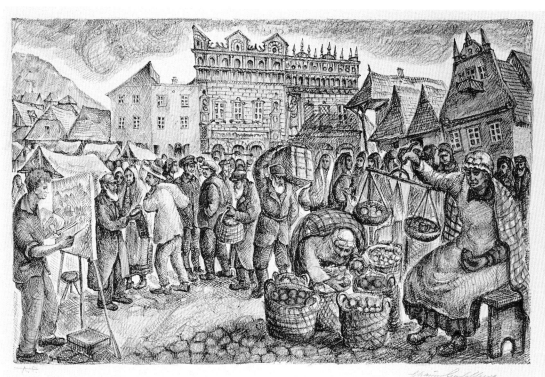

Parents II, 1972
Engraving on ivory
Arches paper, 21/90
42.6×55 cm (16¾×21⅝ in.)
Signed lower right:
Chaim Goldberg; signed in
plate lower left: *Ch Goldberg*
91.57.24

Goldberg, the ninth of eleven children, was born to a poor, pious, and learned shoemaker in Kazimierz, a Hassidic shtetl renowned in Eastern Europe for composers of Hassidic music and generations of great rabbis. This image of the artist's parents began as a drypoint and ended up eight states later as an engraving. All the prints and eight trial state proofs were hand pulled by Goldberg on an Italian press at his studio.

Marketplace, 1969
Hand-colored lithograph on
ivory wove paper, A.P.
36.8×54.4 cm (14½×21⅜ in.)
Signed lower right:
Chaim Goldberg
91.57.26

The marketplace was a hub of shtetl life and a place where Jews and non-Jews mingled. At the left the artist is depicted painting the bustling scene in the main square of Kazimierz, Poland, as he remembered it from his youth. Severely damaged by the Nazis, this square was faithfully reconstructed after the war.

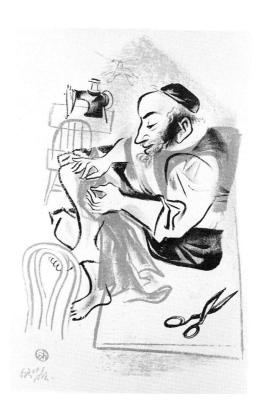

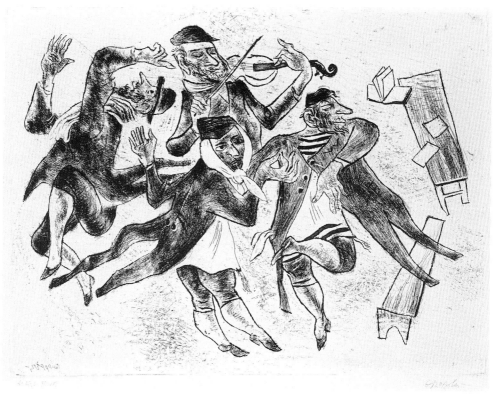

WILLIAM GROPPER

1897–1979

Graphic artist, painter, cartoonist, book illustrator,* teacher, designer of stained-glass windows and murals. Born Lower East Side, New York. Studied with Robert Henri and George Bellows at Ferrar School, 1912–13; at National Academy of Design; New York School of Fine and Applied Art, all New York. Staff artist, *New York Tribune*, 1919–21; *World* (New York), 1925–27. Staff cartoonist for *Freiheit*, 1925–48. Painted murals for the W.P.A./F.A.P. and in post offices for the Treasury Relief Art Project. Commented on political and social issues through his art. During World War II focused on anti-Nazi themes.

Untitled
(The Tailor)
Color lithograph on ivory wove paper, 26/120
35.8 × 27.8 cm (14⅛ × 10⅞ in.)
Signed lower left: *Gropper*
91.57.27

Gropper's barefoot tailor wears the payess (earlocks) and yarmulke (skull cap) of the pious shtetl male. Gropper also portrayed immigrant needle-trade workers in America with illustrations for *Under the Mangle* by P. Yuditch (1954).

Hassidic Dance
Etching on ivory Rives paper,
Artist Proof
38 × 56 cm (14⅞ × 22 in.)
Signed lower right and in plate lower left: *Gropper*
91.57.28

Working on a Ford Foundation Fellowship award in Los Angeles at the Tamarind Lithography Workshop in 1967, Gropper completed three suites, *The Shtetl, Unfinished Symphony*, and *Sunset Strip*. Similar to Tamarind number 1918 from *The Shtetl* series, this whimsical and spirited etching was one of the first such prints Gropper made and was part of the portfolio *Gropper: Twelve Etchings*, 1965, printed in New York by Emiliano Sorini (Helzel, *Narrative Imagery*, p. 73). Additional etchings were printed from each plate.

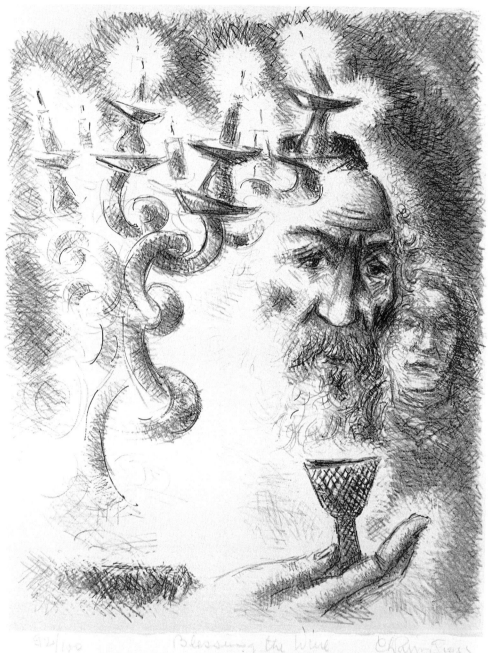

924/150 Blessing the Wine Chaim Gross
 66

CHAIM GROSS

1904–1991

Sculptor, watercolorist, lithographer, book illustrator,* teacher. Born in Wolowa, Carpathian Mountains, Austria-Hungary. To the United States, 1921. Studied at Arts and Crafts School, Vienna; the Educational Alliance Art School, New York; with Elie Nadelman at Beaux-Arts Institute of Design, New York, 1925; with Robert Laurent at Art Students League, New York, 1927. Taught at the Educational Alliance Art School, 1927–89; at the New School of Social Research for forty years. Won numerous prizes. Work represented in major museums.

Blessing the Wine, 1966
Color lithograph on ivory
wove paper, 92/100
57.5 × 46.5 cm (22⅝ × 18¼ in.)
Signed and dated lower right:
Chaim Gross '66; inscribed
lower center: *Blessing the Wine*
91.57.29

The kiddush prayer is recited on Sabbaths and holy days before drinking wine. It emphasizes God's creation of the world and the exodus from Egypt. "Blessed are You, Lord our God, King of the Universe, Who creates the fruit of the vine."

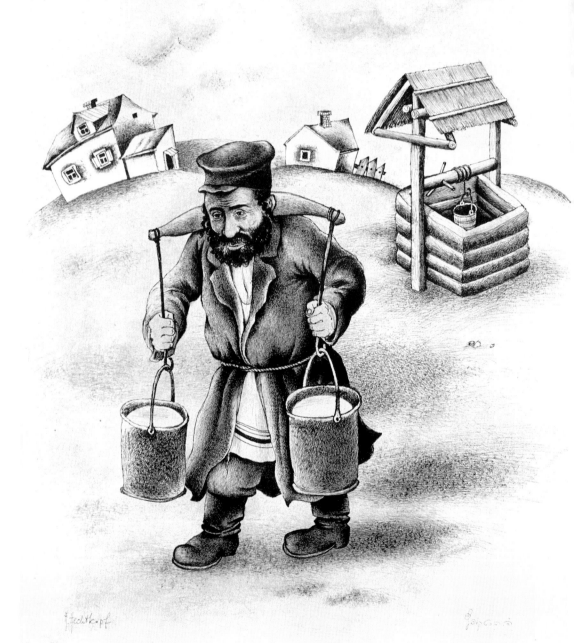

HENRYK HECHTKOPF

b. 1910

Painter, graphic designer, illustrator. Born in Warsaw, Poland. Studied at Warsaw University, 1929; Warsaw Art Academy, 1930. Stage manager for Central Film Studios, Lodz, 1950–57. To Israel, 1957. Taught at the High School of Arts, Tel Aviv. Awarded the prize for young artist, Warsaw, 1925; prize for painting, Bat-Yam, Israel, 1965; first prize in an international competition for the Warsaw Ghetto Uprising poster, published in five languages (see Florence B. Helzel and Eileen Battat, *Witnesses to History: The Jewish Poster, 1770–1985* [Berkeley, Calif.: Judah L. Magnes Museum, 1989], pp. 102–3). This design also appeared on a postage stamp issued by the Polish government to commemorate the uprising. Work represented at Yad Vashem, Jerusalem. Illustrated 260 books, including Bible stories, Jewish tales, and works especially for children.

Water Carrier, 1965
Pen and ink on ivory
wove paper
42 × 33 cm (16½ × 13 in.)
Signed lower left:
H. Hechtkopf; signed in
Hebrew lower right
91.57.30

This is one of thirty-four drawings Hechtkopf titled *Yidishe Parnoses* (Jewish Occupations). Hechtkopf's letter of June 27, 1992, to the author explained his imagery: "I designed a series of Jewish folklore types like I remembered them in Poland in the years after the first World War to 1939, when I lived in Warsaw. . . . I see them still now before my eyes like living in the poor parts of the Jewish quarter of Warsaw and in other little shtetls around Warsaw."

In *Life Is with People*, a water carrier is described as follows: "Another important unskilled laborer of the Shtetl is the watercarrier, who delivers drinking water from the town pump or well. If he boasts a horse, the water is drawn in a huge cask on four wheels. Otherwise he carries it in pails, either on a shoulder pole or by hand, to those who have pennies for payment. The others must fetch it themselves" (Zborowski and Herzog, p. 243).

SAM HERCIGER

1917–1981

Sculptor, printmaker. Born in Zawiercie, Poland. To Antwerp, Belgium, 1937. Studied at the Royal Academy of Fine Arts, Antwerp, pupil of the sculptor Willie Kreitz. Deported to Auschwitz, survived, and returned to Antwerp. Received a medal and diploma of honor at the international exhibition *Annuale Italiana d'Arte Grafica* at Ancona, Italy, 1968. To Israel, 1979. Complete collection of his prints donated to the Jewish Museum of Belgium, Brussels.

Untitled
(The Prayer), 1972
Linocut on ivory
wove paper, 10/15
32.5 × 28 cm (12¾ × 11 in.)
Signed lower right:
Sam Herciger
91.57.31

For many years Herciger buried scenes of his shtetl in his subconscious. However, in a series of twenty linocuts, *Mein Shtetl*, he returned to his roots for his imagery.

It is the woman of the house who lights the Sabbath candles on Friday just before sunset, praying as she does so, "Blessed art Thou, Lord our God, King of the Universe, Who hast hallowed us by His Commandments and commanded us to kindle the Sabbath light."

8/15 Luis Hernandez

Untitled
(The Tailor)
Linocut on ivory
wove paper, 8/15
47.2 × 28.5 cm (18⅝ × 11¼ in.)
Signed lower right:
Sam Herciger
91.57.32

The tailors of the shtetl were divided into several classes: First, the tailors who made the rounds of the villages doing on-the-spot work. . . . Second, tailors who worked on second-hand clothes for the shtetl stores and third, tailors who were the big shots of the street because they made clothes to order for the well-to-do citizens of the town" (Roskies and Roskies, *The Shtetl Book*, p. 129).

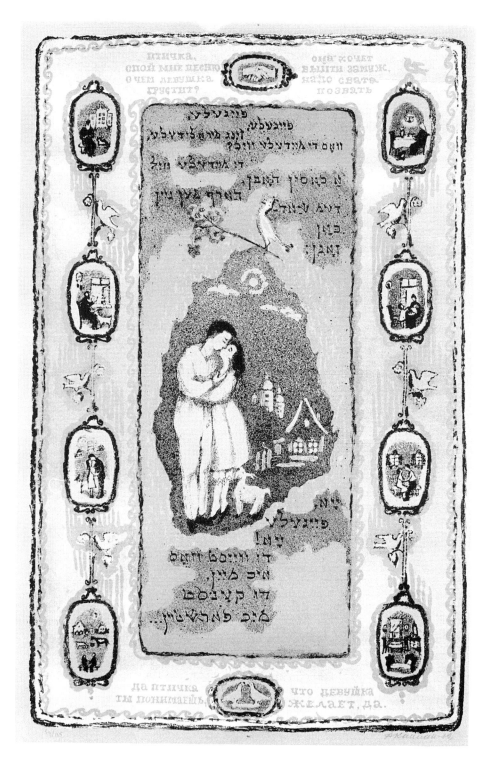

ПТИЧКА, ОПОЙ МНЕ ПЕСНЮ, О ЧЕМ ДЕВУШКА ГРУСТИТ?

ОНА ХОЧЕТ ВЫЙТИ ЗАМУЖ, НАДО СВАТА ПОЗВАТЬ

ДА ПТИЧКА ТЫ ПОНИМАЕШЬ, ЧТО ДЕВУШКА ЖЕЛАЕТ, ДА.

ANATOLY KAPLAN

1902–1980

Draftsman, printmaker, stage designer, painter, ceramicist. Born in Rogachev, Byelorussia. Studied at Leningrad Academy of Fine Arts, 1921–27; lithography at experimental workshop at Leningrad Artists Union, 1930s. Commissioned to arrange the Jewish exhibit in the Leningrad Ethnological Museum, 1941. Illustrated works by Sholom Aleichem, including "The Bewitched Tailor," "Tevye the Milkman," and "Kasrilevka." Also illustrated Yiddish folk songs, such as "Song of Songs" and "The Little Goat."

Faigele, Faigele
(Little Bird, Little Bird)
Color lithograph on ivory
wove paper, 54/125
62.2 × 47 cm (24½ × 18½ in.)
Signed in Russian lower right
91.57.34

Vignettes of shtetl life surround the embracing couple. In Russian and Yiddish Kaplan writes:

Little bird, little bird, sing me a song
The kind of song that a girl wants
A little girl wants a groom
So we must have a matchmaker.

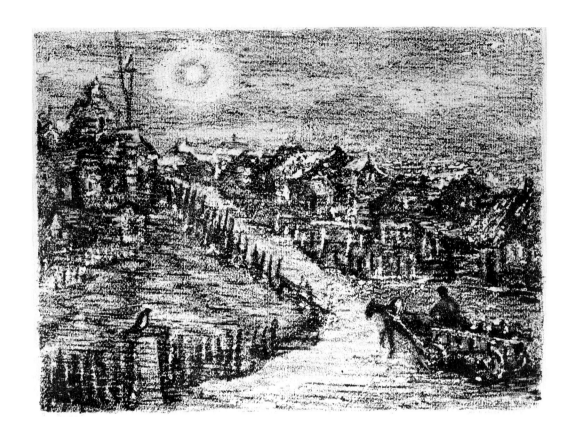

Going Home
Lithograph on
ivory wove paper
46.7 × 56.2 cm (18⅜ × 22⅛ in.)
Signed in Russian lower right;
inscribed in Russian:
Going Home
91.57.35

Between 1957 and 1961 Kaplan produced a series of lithographs based on Sholom Aleichem's story "Tevye the Milkman." This print depicts a moonlit scene of the town of Boiberek under snow and Tevye returning home with his horse and cart. The popular musical play and motion picture *Fiddler on the Roof* was based on this story. Immortalized by Sholom Aleichem, Tevye the Milkman is perhaps the archetypal shtetl personality.

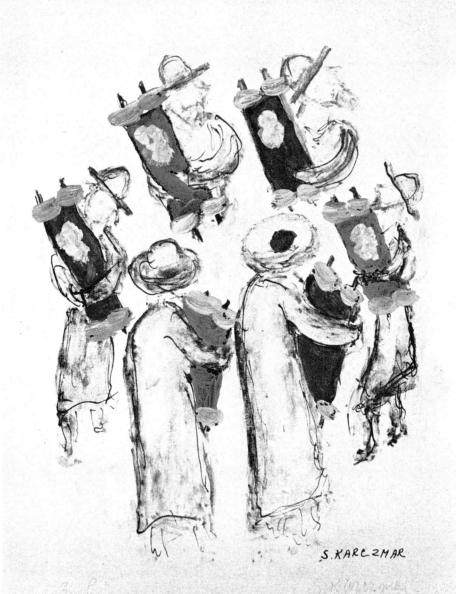

S. KARLZMAR

SIMON KARCZMAR

b. 1903

Painter. Born in Warsaw, Poland. Studied at an art school in Warsaw; at the Ecole Nationale des Beaux-Arts in Paris. With partisans in Nice during Nazi occupation. To Israel, 1951; to the United States. *My Grandfather's Village*, an exhibition of twenty-two oils and pastels, held at Theodore Herzl Institute, New York, 1963.

Untitled
(Simchat Torah)
Hand-colored
photo-offset lithograph
32.8 × 21.9 cm (12⅞ × 8⅝ in.)
Signed lower right:
S. Karczmar; signed lower
left in Hebrew
91.57.36

During his childhood, Karczmar spent many vacations at his grandfather's shtetl, Dzieweniszky in Lithuania. The traditional Jewish ceremonies he witnessed there made a lasting impression on him and are reflected in much of his art. This print illustrates Simchat Torah (Rejoicing in the Law), one of the most joyous of Jewish holidays. It celebrates the completion of the annual cycle of Torah readings.

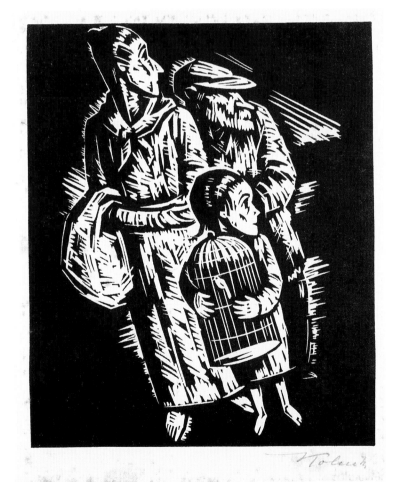

ARTHUR KOLNIK

1890–1971

Painter, printmaker, draftsman, book illustrator. Born in Stanislavov, Galicia. Studied with Joseph Mehoffer at the Academy of Fine Arts, Cracow, 1908–14. Won numerous prizes and a silver medal while at the academy. To Czernowitz, capital of Bucovina, 1918. Participated actively in cultural life of Jewish community. To Paris, 1931. Illustrated numerous albums, including *A travers les lunettes* in 1928, woodcuts illustrating the fables of Eliezer Steinbarg, and *The Transmigration of a Melody*, by I. L. Peretz.

Untitled
(Sabbath)
Woodcut on ivory
wove paper, 7/200
14.1 × 10.7 cm (5½ × 4¼ in.)
Signed lower right: *Kolnik*
91.57.39

Kolnik's still life displays essential components of the traditional Sabbath table—candles and challah.

Untitled
(The Long Journey)
Woodcut on ivory wove paper
25.1 × 16 cm (9⅞ × 6⅜ in.)
Signed lower right: *Kolnik*
91.57.37

After settling in Paris in 1931, Kolnik's subject matter mainly reflected Jewish life of Eastern Europe. This woodcut closely resembles the artist's painting *The Long Journey*.

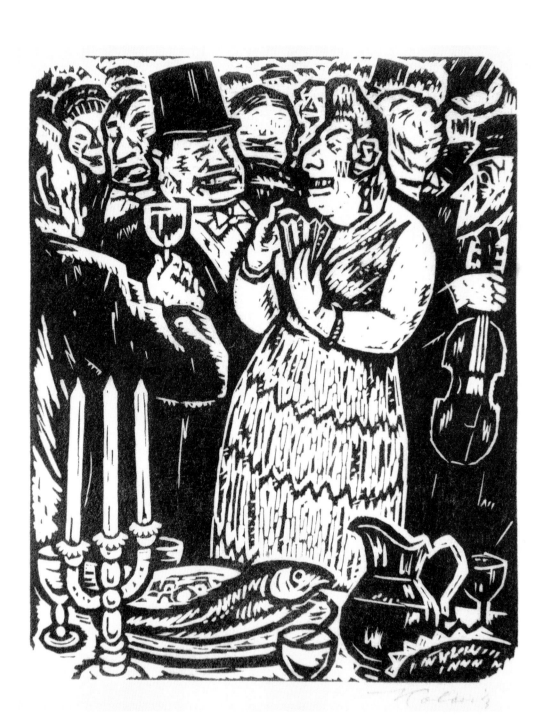

The People from Kiev at the Wedding, 1948
(No. 12 from *The Transmigration of a Melody*)
Woodcut on ivory wove paper
21 × 18 cm (8¼ × 7⅛ in.)
Signed lower right: *Kolnik*
91.57.38

In Kolnik's introduction to the series *The Transmigration of a Melody*, he remarks: "You will certainly notice that I am not entirely faithful to Peretz's story . . . but to Peretz himself perhaps I am" (A. Kolnik, *Métamorphoses d'une mélodie*, twenty woodcuts, inspired by Hassidic stories by I. L. Peretz, in Yiddish [Paris, 1948]).

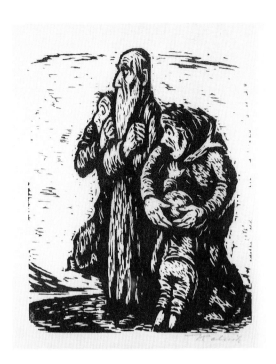

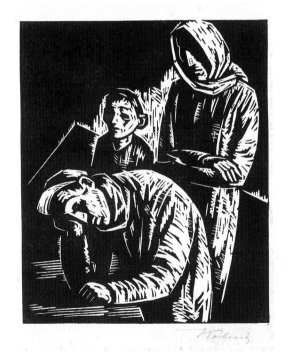

Last Confession, 1948
(No. 6 from *The Transmigration of a Melody*)
Woodcut on ivory rice paper
21 × 17.8 cm (8¼ × 7 in.)
Signed lower right: *Kolnik*
91.57.40

Kolnik's woodcuts are described as "showing a sympathetic unconcern for the proportions of the human body, tending toward a sad grotesqueness, toward distortion that—in one stroke—characterizes his figures" (H. Gamzu, *Arthur Kolnik* [Tel Aviv Museum, Beit Dizengoff, 1968]).

Untitled
(Despair)
Woodcut on buff laid paper
24.8 × 16.5 cm (9¾ × 6½ in.)
Signed lower right: *Kolnik*
91.57.41

Here Kolnik presents a family in anguish. This dramatic scene characterizes the artist as an expressionist.

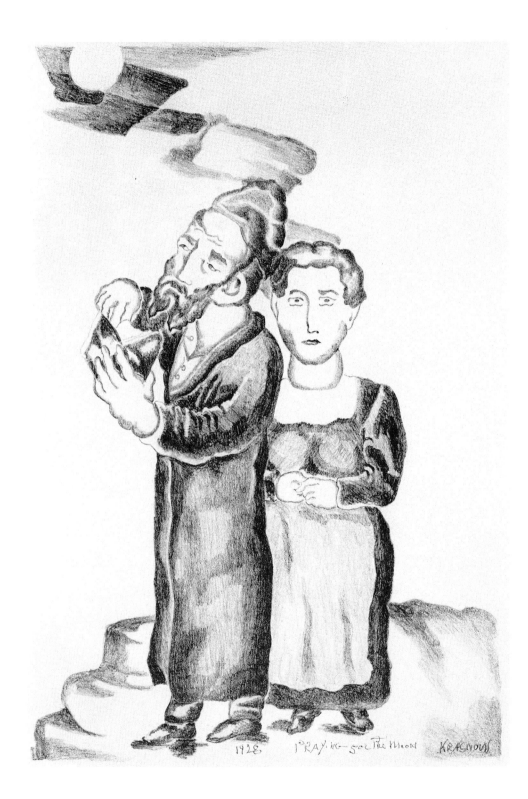

1928. PRAYING 50r THE MOON KRASNOW

PETER KRASNOW

1887–1979

Painter, sculptor, printmaker, draftsman, watercolorist. Born, Zawill, Ukraine, son of a house painter. To the United States, 1907. Graduated, Art Institute of Chicago School, 1916. Settled in Los Angeles, 1922. Worked in France, almost exclusively in watercolors, 1931–34. Exhibition, *Peter Krasnow: A Retrospective Exhibition of Paintings, Sculpture, and Graphics*, Judah Magnes Museum, 1977. Numerous solo and group exhibitions.

Praying for the Moon, 1928
Lithograph on ivory
wove paper
44.2 × 30.9 cm (17⅜ × 12⅛ in.)
Signed lower right: *Krasnow*;
dated and inscribed
lower center:
1928 Praying for the Moon
91.57.42

In the stylized modernism of the 1920s, Krasnow illustrates the new moon, or Rosh Chodesh, which symbolizes hope and joy. A prayer of thanksgiving is recited to welcome the new month.

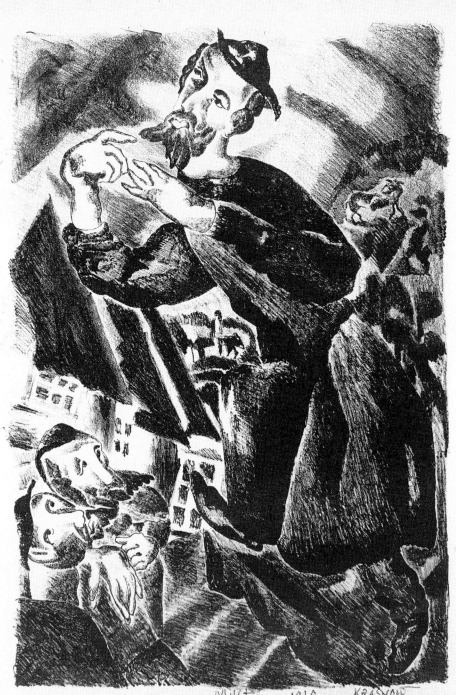

Mystic. 1928 Krasnow

Mystic, 1928
Lithograph on buff laid paper
35.3 × 25.9 cm (13⅞ × 10¼ in.)
Signed lower right: *Krasnow*;
inscribed and dated
lower center: *Mystic. 1928*
91.57.43

In his yearning for the nearness of God, the mystic developed magical rites and incantations to bring divinity down to man.

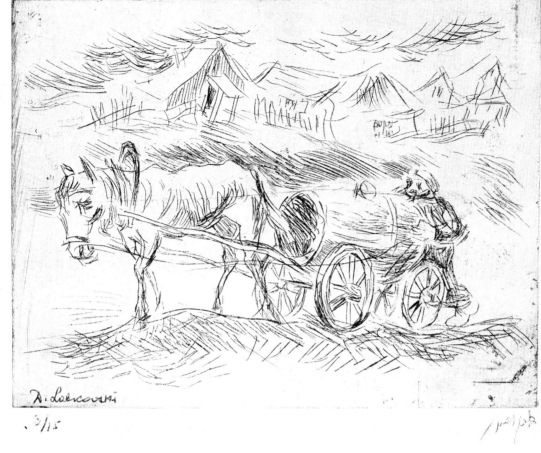

D. Lakcovski

3/15

DAVID LABKOVSKY

1906–1991

Painter, draftsman. Born in Niebel, Russia. Spent youth in Vilna, Lithuania. Painter and decorator for State Jewish Theater in Moscow, 1933. Studied at Academy of Art, Leningrad, 1936. Sent to a concentration camp in the Stalin era, 1941. To Vilna after release from camp, 1946. To Israel, 1958. Solo show devoted to centenary of Sholom Aleichem, Israel, 1959; organized exhibition at Yad Vashem Museum, Jerusalem, on the subject of the shtetl, 1965. Published album, *Sholom-Aleichem and His Heroes*, 1966. Most of his work is on permanent display at the David Labkovsky Museum of Jewish Art, Ramat Gan, Israel.

Untitled
(Water Carrier)
Etching on ivory
wove paper, 3/15
24.2 × 29.6 cm (9½ × 11⅝ in.)
Signed lower left:
D. Labkovski; signed in
Hebrew lower right
91.57.45

For thirty-two years in a tiny apartment in Safed, Labkovsky drew on his vivid memory to create hundreds of charcoal, watercolor, and gouache drawings of shtetls, the Jewish neighborhoods of Vilna, and Jews trapped in the Holocaust. This etching is possibly a sketch for his painting *Methuselah* of 1972.

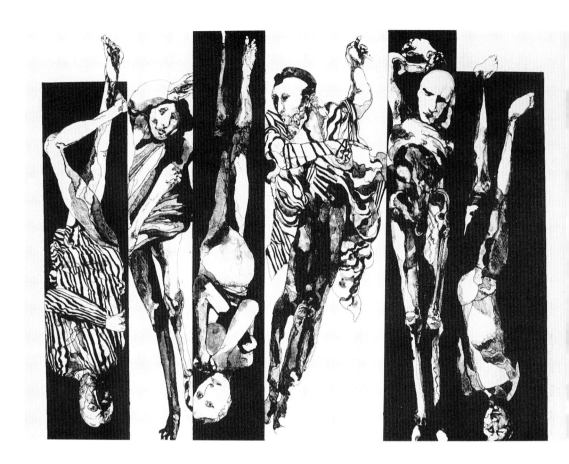

JACOB LANDAU

b. 1917

Printmaker, watercolorist, book illustrator, designer of stained-glass windows, professor of art, lecturer. Born in Philadelphia. Studied at Philadelphia College of Art; New School for Social Research, New York; Académie Julian, Paris; Académie de la Grande Chaumière, Paris. Taught at the School of Visual Arts, New York; Philadelphia College of Art; Pratt Institute, New York. Won many awards, including Governor's Award for Distinguished Service in Arts and Education, New Jersey, 1989. Exhibition, *The Prophetic Quest*, Magnes Museum, June 6–September 19, 1993.

Holocaust, 1968
Lithograph on
Arches paper, 39/40
38×51.5 cm (15×20¼ in.)
Inscribed and signed lower
right: *Holocaust, Jacob Landau*
91.57.46

This lithograph is one of six Landau produced for the Union of American Hebrew Congregations for reproduction in *Out of the Whirlwind: A Reader of Holocaust Literature*, edited by Albert H. Friedlander. Landau's grim figures are a result of his meeting concentration-camp survivors and are a forbidding reminder that the physical existence of shtetls ended in the gas chambers and concentration camps of the Third Reich.
(See Helzel, *Narrative Imagery*, p. 89.)

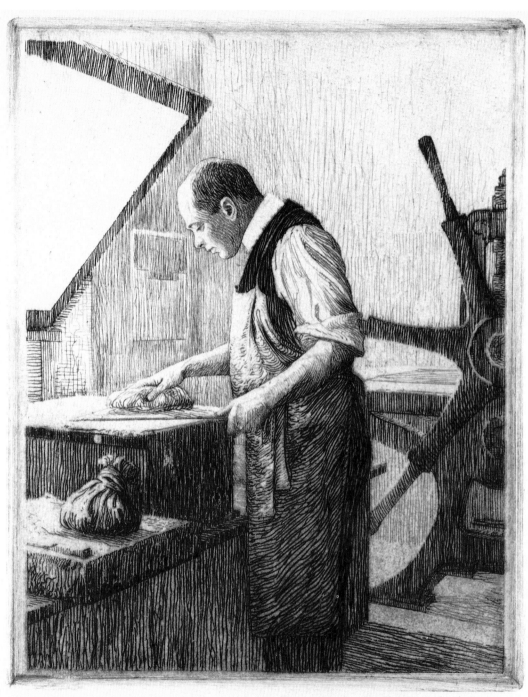

EPHRAIM MOSHE LILIEN

1874–1925

Painter, printmaker, book illustrator* and designer.
Born in Drohobycz, Austrian Galicia. Studied at Academy of Fine Arts, Vienna. With Martin Buber and others, founded Berlin publishing house Jüdischer Verlag, 1902; with Boris Shatz and others, founded Bezalel Academy of Arts and Design, Jerusalem, 1905. First noted Jewish artist active in Zionist movement. Illustrated twelve books including *The Books of the Bible*, published in 1923, his last major work.

Bei der Arbeit
(At Work)
Etching on buff wove paper
37.5 × 29.5 cm (14¾ × 11⅝ in.)
Signed lower right: *e. m. Lilien*
91.57.49

Lilien's self-portrait is the frontispiece of Lothar Brieger's biography of the artist, *E. M. Lilien* (Berlin and Vienna: Benjamin Harz, 1922).

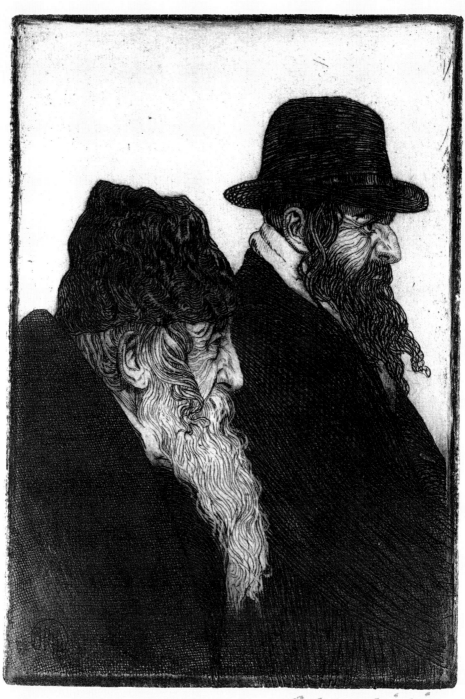

Jews of Galicia, ca. 1910
Etching on buff laid paper
34 × 27.2 cm (13⅜ × 10¾ in.)
Signed lower right: *e.m.Lilien*
91.57.50

This etching appears on page 30 of Lothar Brieger's biography of the artist. Brieger describes Lilien's homeland: "Life is difficult—almost hopeless. An almost logical addition to the poor condition of the exterior fate is that almost nowhere else is Judaism more conservative as here—where the rabbi is still the teacher and leader of the people—and that the complete Jewish school, the Talmud school, completely sets the decisive tone of the spiritual physiognomy of the entire Jewish population of Galicia."

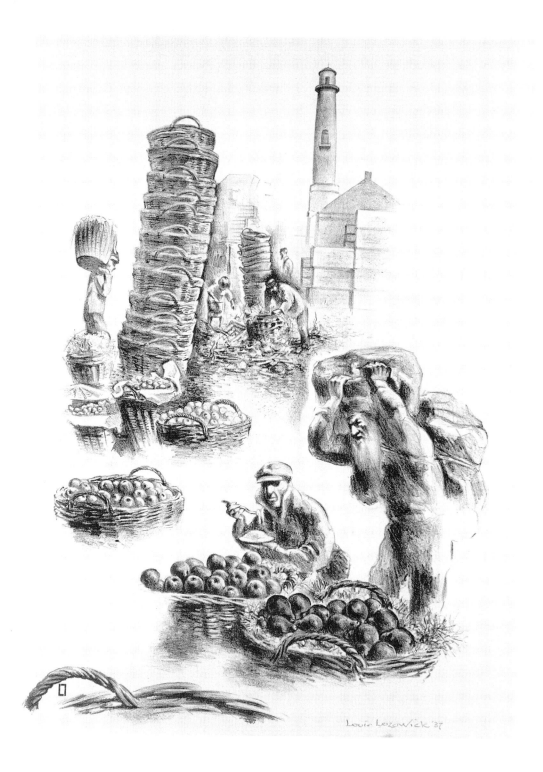

Louis Lozowick '37

LOUIS LOZOWICK

1892–1973

Painter, printmaker, lecturer, writer, teacher of lithography. Born in Ludvinovka, Russia. To the United States, 1906. Studied at Kiev Art School, 1903; National Academy of Design, New York, 1912–15; Ohio State University, 1915–18. Taught at American Artists School and Educational Alliance Art School, both New York. Awarded first prize for lithography, Philadelphia Print Club, for *Brooklyn Bridge*. His articles on Jewish art and artists appeared in *The Menorah Journal* and other periodicals. Worked on W.P.A./F.A.P. projects, 1934–40. Published *One Hundred Contemporary American Jewish Painters and Sculptors*, 1947. Lectured, wrote, and traveled worldwide during the 1950s, 1960s, and early 1970s.

Warsaw Market, 1937
Lithograph on ivory wove
paper, edition of 20
42.8 × 33.3 cm (16⅞ × 13⅛ in.)
Signed and dated lower right:
Louis Lozowick '37
91.59.1

This print is a rare record of Lozowick's impressions during a 1934 visit to Poland, one of several trips he made to Europe in the 1930s.

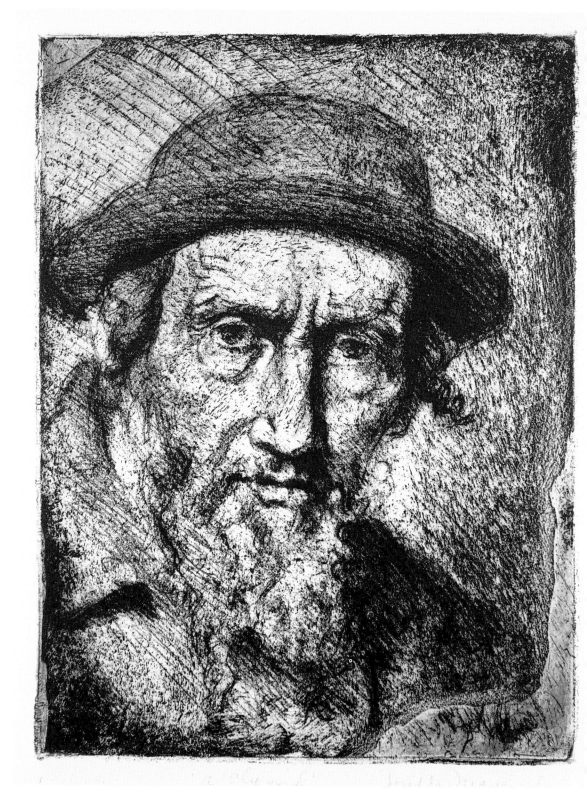

JOSEPH MARGULIES

1896–1984

Painter, etcher, portraitist. Born in Vienna. Studied at Cooper Union; National Academy of Design; with Joseph Pennell at Art Students League, all New York; Ecole Nationale des Beaux-Arts, Paris; and with Maynard Waltner, Vienna. Member of Art Students League, New York. Won many awards, including Gold Medal for etching, Grand National Exhibition, American Professional Artists League, 1965. Among the many prominent portraits he painted were those of former presidents Dwight D. Eisenhower and Richard Nixon.

A Chassid
Etching on ivory
wove paper, 150/250
33.3 × 27.7 cm (13⅛ × 10⅞ in.)
Signed lower right: *Joseph Margulies*; inscribed lower
center: *A Chassid*
91.59.2

Hasidism, following the teachings of its founder, the Baal Shem Tov, focuses more on the individual's personal relationship with God and with fellow human beings than on the intricacies of Jewish law.

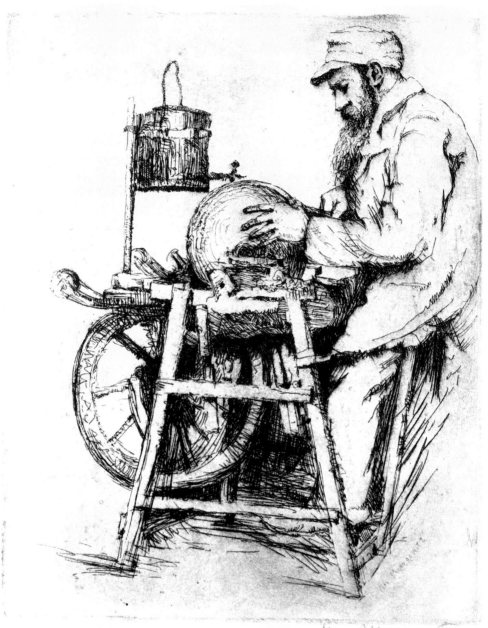

WILLIAM MEYEROWITZ

1898–1981

Painter, printmaker. Born in Ukraine, son of a cantor.
To the United States, 1908. Studied at National Acad-
emy of Design, New York, 1912–16. Won first prize and
gold medal for painting *Exodus*, Contemporary Artists
of New England, 1944. Worked as a muralist in the
W.P.A. Painted a portrait of Albert Einstein; commis-
sioned by Supreme Court Justice Oliver Wendell
Holmes for a portrait. Member of National Academy of
Design, 1943.

Untitled
(Scissors Grinder)
Etching on ivory wove paper
23 × 19.3 cm (9⅛ × 7⅝ in.)
Signed lower right and in plate
lower right: *Wm Meyerowitz*
91.59.4

Shtetl dwellers most often were small-time merchants or
engaged in skilled trades, such as this scissors grinder.

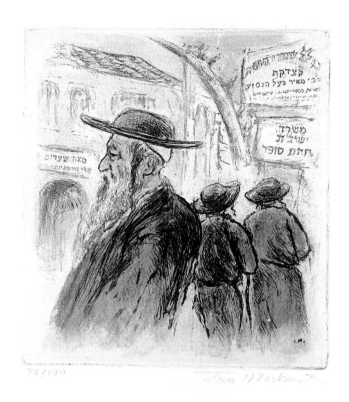

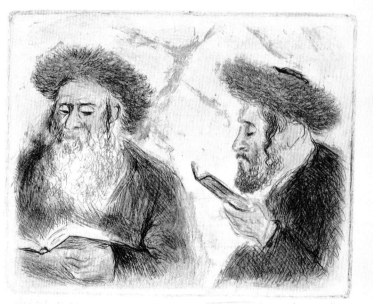

IRA MOSKOWITZ

b. 1912

Printmaker, book illustrator. Born in Turka, Poland. To the United States, 1927. Studied at Art Students League, New York, 1930–33. Worked in W.P.A. Awarded Guggenheim Foundation Fellowship, 1943; First Purchase Prize, Library of Congress, 1945. Published *Patterns and Ceremonials of the Indians of the Southwest*, 1949. Published portfolios of etchings, *Torah I* and *Torah II*, 1970. Collaborated with Isaac Bashevis Singer, illustrating many stories, including "The Hasidim," 1973, "A Little Boy in Search of God," 1976, "Reaches of Heaven," 1980, and "Satan in Goray," 1981.

Mea Shearim, 1973
Hand-colored etching on ivory
wove paper, 72/100
28.5 × 25.6 cm (11¼ × 10⅛ in.)
Signed lower right:
Ira Moskowitz;
initialed in plate lower right
91.59.5

In 1936 Moskowitz traveled to Palestine, where he worked for over two years creating drawings with a Jewish theme. The extremely pious of the Mea Shearim district of Jerusalem were his favorite subjects.

Two Jews Studying, 1970
Hand-colored etching on ivory
wove paper, A.P.; edition of 100
19 × 23.3 cm (7½ × 9⅛ in.)
Signed lower right:
Ira Moskowitz; inscribed
lower left: *Artist Proof
Sample for Coloring*
91.59.6

Moskowitz depicts two Jews wearing the shtreimel (wide-brimmed black hat edged in fur) and payess (long earlocks) worn by the very orthodox and by Hasidim.

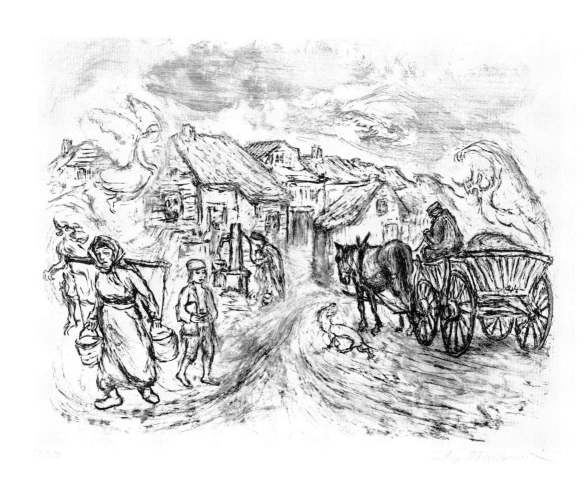

The Village of Okup, 1980
(No. 1 from *Reaches of Heaven*)
Etching on Arches paper,
82/250
31.5 × 45.2 cm (12⅜ × 17¾ in.)
91.59.8

This print is one of twenty-four etchings from the portfolio *Reaches of Heaven*, published by Landmark Press, New York, with a text by Isaac Bashevis Singer. In this work, Singer gives his impressions of the spiritual achievements of Rabbi Israel Baal Shem Tov, the founder of Hasidism.

Moskowitz's dedication of the portfolio reads: "To Faye and Nathan Hurvitz, who express their honor and love for our people of the destroyed Eastern European shtetl by the art objects they display in their home."

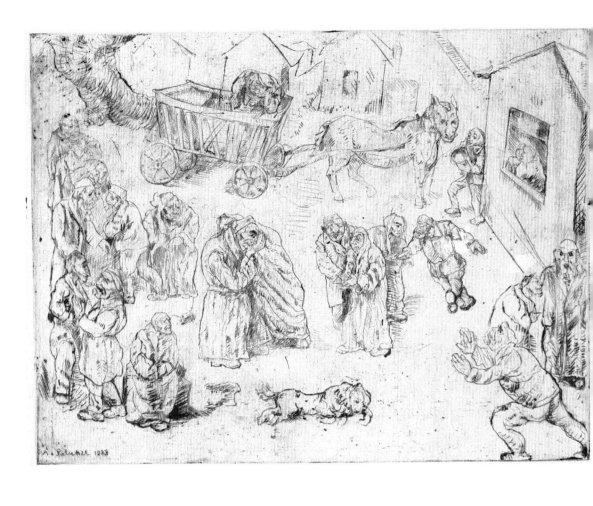

AVRAHAM PALUKST

1895–1926

Graphic artist. Born in Ritova, Lithuania. Grandson of a rabbi. Studied at Antokolsky Academy, Vilna, 1912. To Germany as a prisoner of war, 1915. Began a new life in Berlin, 1917. Became a member of a circle of Jewish artists, which included Jacob Steinhardt, Joseph Budko, and Hermann Struck. Main theme throughout work is the shtetl. Suffered mental depression; vanished around 1926. Art given to Struck and Steinhardt by Palukst taken by them to Israel. Nazis destroyed Palukst's works in German museums and private collections.

Market in the Shtetl, 1923
Drypoint on ivory wove paper
26.8 × 34.5 cm (10⅝ × 13⅝ in.)
Signed and dated in plate
lower left: *A. Palukst 1923*
91.59.10

This drypoint was part of a 1981 exhibition of Palukst's work depicting the shtetl, held at the Shaar-Zion Library, Tel Aviv, and in 1982 at the State Historical Museum, Düsseldorf. Palukst crowds his composition, emphasizing the tumult of a market day: people are engaged in animated transactions and discussions.

In 1924 the German art historian Max Osborn described Palukst's art as "the artist's fantasy . . . nourished exclusively from his childhood memories of the Jewish 'shtetl' in Russia" (*Palukst, 1895–1926* [Tel Aviv: Eked, 1982], p. 14).

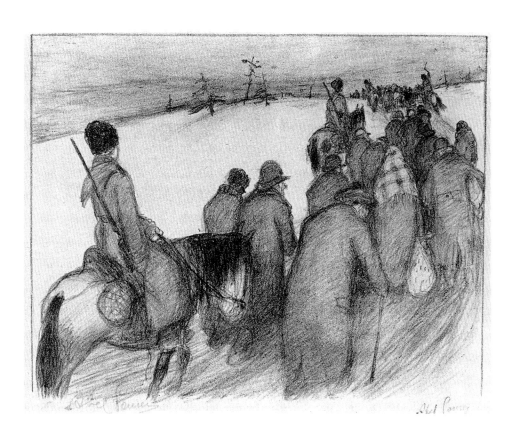

ABEL PANN

1883–1963

Painter, cartoonist, graphic artist, teacher. Born in Kreslavka, Latvia. Studied in Odessa, in Vilna, and in Paris under Bouguereau and Toulouse-Lautrec. To Israel, 1913. Taught at Bezalel Academy of Arts and Design. Pann's chief work was illustrations of the Bible.

The Long Trail
Lithograph on tan wove paper
29 × 35 cm (11⅜ × 13¾ in.)
Signed lower left and in plate
lower right: *Abel Pann*
91.59.11

Pann's drawings of the czarist pogroms appeared in a portfolio, *The Tear Jug: Twenty-four Designs by Abel Pann*, published by the National Museum, "Bezalel," Jerusalem, 1926. *The Long Trail* is nearly identical to number 22, *En Route to Siberia*, from that portfolio.

ПЕРКЕЛЬ 070

GREGORY PERKEL

b. 1939

Painter, printmaker, book illustrator. Born Vinnitsa, USSR. To Moscow, 1946. Graduated State Teacher's Institute, Fine Art and Graphic Department, Moscow, 1964. Member of Artists' Union of the USSR, 1969. Created album of twelve lithographs based on Leo Tolstoy's *War and Peace* and an album of seventeen lithographs based on short stories by Sholom Aleichem, 1973. To the United States, 1977. Exhibition of paintings, *Totems, Parts, and Obsession*, New York, 1980.

Sholom Aleichem, "Kasrilevke," 1970
Color lithograph on ivory wove paper, 13/15
65.5 × 52.4 cm (25¾ × 20⅝ in.)
Signed lower left: *Grigory Perkel*; signed and dated in Russian lower left; inscribed lower center in Russian: *Sholom Aleichem 'Kasrilevke'*; signed and dated in plate in Russian lower left
91.59.12

This lithograph illustrates the fictitious shtetl Kasrilevke, created by the Yiddish novelist and humorist Sholom Aleichem. Kasrilevke, the scene of many of his works, is a town of poor but happy Jews who are always rushing about trying to earn enough for the Sabbath.

From 1970 to 1972, Perkel worked on lithographs focusing on Jewish folklore. In 1974 he made five lithographs, *Parables*, which depicted his reflections on the purpose of life. The work was forbidden by the Artists' Union because it was not imbued with the spirit of socialist realism.

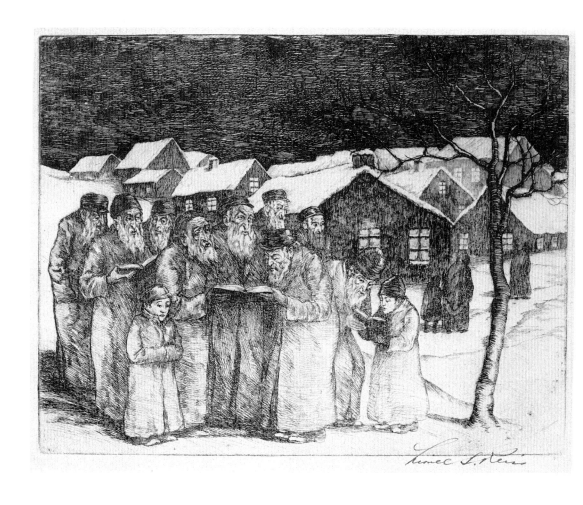

LIONEL S. REISS

1894–1988

Painter, draftsman, printmaker, book illustrator,* water-
colorist, author, teacher, lecturer, illustrator for advertis-
ing agencies. Born in Jaroslav, Poland. To the United
States, 1899. Studied in New York, Paris, and Berlin. Art
director, Goldwyn Pictures Corporation, 1914–19. Trav-
eled abroad making an ethnic study of the Jew, covering
Europe, North Africa, and the Near East, 1930–32. Pub-
lished three collections of work: *My Models Were Jews*,
1938, *New Lights, Old Shadows*, 1954, and *A World at
Twilight*, 1971.

Blessing the New Moon
Etching on tan wove paper
24.8 × 32.1 cm (9¾ × 12⅝ in.)
Signed lower right:
Lionel S Reiss
91.59.15

This group of men and boys are reciting the prayer of
thanksgiving to welcome the new moon, which symbol-
izes hope and joy.

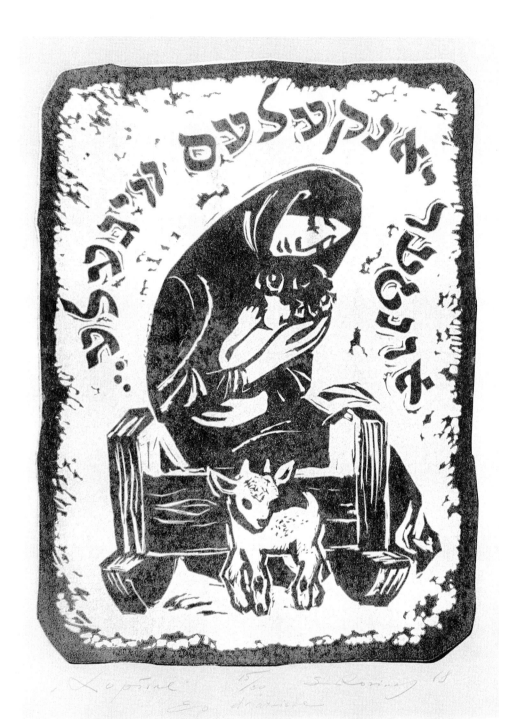

SAMUEL ROZIN [SAMUELIS ROZINAS]

b. 1926

Printmaker, book illustrator. Born in Kovno, Lithuania. Studied at Institute of Art, Vilna, Lithuania, 1949–51; USSR Academy of Art, Leningrad, 1951–55. Awarded USSR Silver Medal for woodcuts depicting state's economic achievements, 1961; USSR Silver Medal, USSR Academy of Art, for series of woodcuts, *Lithuanian Partisans*, earning him a trip to Italy, 1965. To Israel, 1974. Published an album of prints, *Vilnius*, 1957, album of woodcuts, 1961, and miscellaneous works, 1969. Taught art at WIZO Tsarfat, Ramat Aviv, 1974–91. Work exhibited Los Angeles, New York, Chicago, 1982.

Under Jacob's Cradle, 1968
Linocut on ivory wove
paper, 15/30, A.P.
64.1 × 48.2 cm (25¼ × 19 in.)
Signed and dated lower right:
S Rozinas 68; titled in Hebrew
upper center
91.59.16

Hand printed by Rozin in Vilna, this print is from a series of ten the artist created to illustrate folk songs.

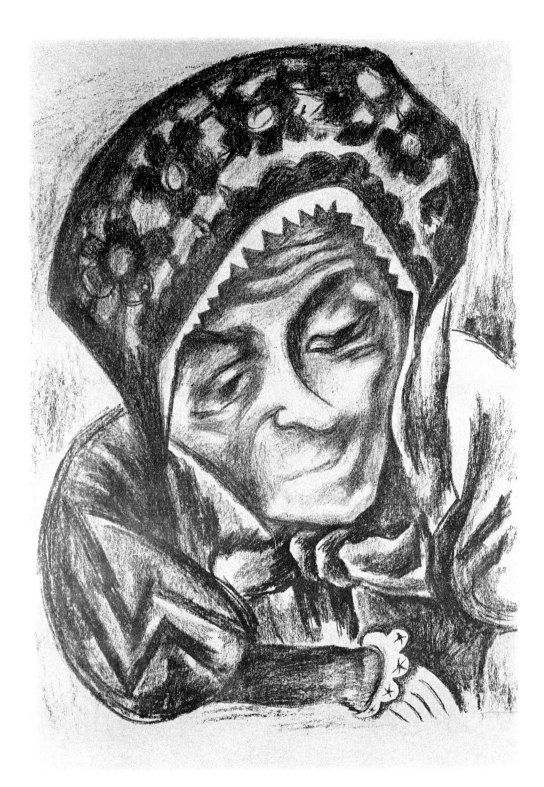

ISSACHAR RYBACK

1897–1935

Painter, draftsman, theater-set and costume designer, book illustrator,* ceramicist. Born in Elisavetpol, Ukraine. Studied at Kiev Academy. Appointed drawing teacher by Central Committee of Jewish Cultural League, 1917. Published *On the Jewish Fields of the Ukrainia* after living for two months in the post-revolutionary Jewish farm collectives in Ukraine, 1926. To Paris, 1926. Died on eve of retrospective exhibition, Paris. Collection of work at Ryback Museum, Bat Yam, Israel.

Untitled
(Woman of Ukraine)
Color lithograph on
tan wove paper
55.7 × 42.2 cm (21⅞ × 16⅝ in.)
Signed lower right: *I. Ryback*
91.59.17

In 1915–16 Ryback participated with the artist El Lissitsky in expeditions financed by the Jewish Historical and Ethnological Society to the shtetls of Ukraine to study Jewish folk art. This lithograph reflects the influence from these trips on Ryback's art.

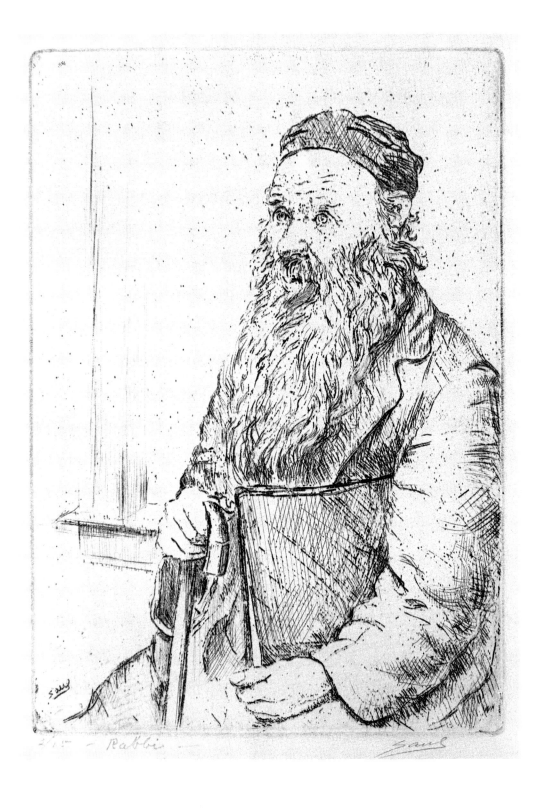

Rabbi

SAUL [SAUL KOVNER]

1904–1981

Painter, watercolorist, printmaker. Born in Rogachev, Byelorussia, Russia. To the United States, 1910. Studied with Ivan Olinsky, Charles Hawthorne, and William Auerbach-Levy at the National Academy of Design, New York, 1920–28. Won the Pennsylvania Academy of the Fine Arts Award for *Child with Instrument*, 1932, Society of American Etchers Award for *Picnic*, and the Art Institute of Chicago Award for *Day of Rest*. First president, American Watercolorists, 1938. To California, 1948.

Rabbi
Etching on buff
wove paper, 2/25
21.9 × 16.8 cm (8⅝ × 6⅝ in.)
Signed lower right and in
plate lower left: *Saul*;
inscribed lower left: *Rabbi*
91.59.18

Saul has been described as "a compassionate man of simple tastes and devoid of affectation. This empathy undoubtedly accounts for the ring of authority found in his many drawings, etchings and lithographs of people engaged in everyday activities" (Janice Lovoos, "The Art of Saul Kovner," *American Artist* [February 1968], pp. 45, 63). Here Saul captures a sense of wisdom and serenity in the facial expression of his rabbi.

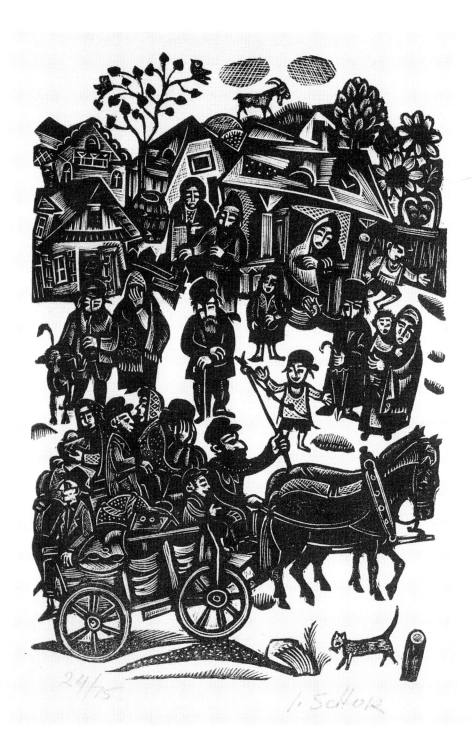

24/75 1. SCHOR

ILYA SCHOR

1904–1961

Painter, book illustrator,* printmaker, designer of jewelry and ceremonial objects. Especially noted for work in silver. Born in Poland, son of a master craftsman and sign painter. Brother died in Warsaw Ghetto. Studied metalcrafts with several masters and at Warsaw Academy of Fine Arts. Associated for three years with Poland's pioneer fresco painter, Felician Korwarski. Studied at Ecole Nationale des Beaux-Arts, Paris. To the United States, 1941. Owned silversmith shop, New York. Illustrated many books, including *Adventures of Mottel, the Cantor's Son*, by Sholom Aleichem, 1953.

Hurray, We're Going to America
Wood engraving on ivory wove paper, 24/75
25.2 × 15.7 cm (9⅞ × 6⅛ in.)
Signed lower right: *I. Schor*
91.59.19

Schor's wood engraving illustrates chapter 11 of *Adventures of Mottel, the Cantor's Son* by Sholom Aleichem: "Well, here is Leyzer with his 'eagles'—three fiery horses. . . . Everyone bustles around, stares at us and cautions us to beware of thieves" (p. 110).

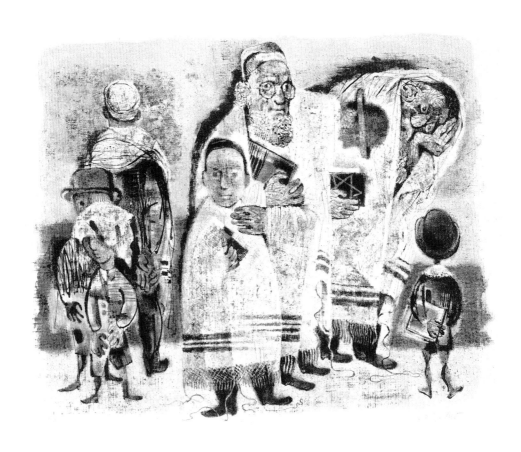

GEORGES SCHREIBER

1904–1977

Painter, illustrator, watercolorist, printmaker, teacher,
author. Born in Brussels, Belgium. Studied at German
Real Gymnasium, Brussels; Arts and Crafts School,
Elberfeld, Germany; fine arts academies, Berlin and
Düsseldorf. To the United States, 1928. Free-lance artist
for newspapers: *Kölner Tageblatt* (Cologne), 1925; lead-
ing Berlin newspapers; contributor to *New York Times*,
World (New York), and the *New York Post*. Free-lance
artist for NBC, 1930–32. Wrote and illustrated many
books, including *Portraits and Self-Portraits*, 1936, and
Ride on the Wind, 1957. Taught at New School for Social
Research, New York, 1958. Graphics retrospective, Ken-
nedy Galleries, New York, 1970.

Age 13, 1962
Color lithograph on ivory
wove paper, 37/50
45 × 62.8 cm (17¾ × 24¾ in.)
Signed lower right: *Schreiber*;
inscribed lower center: *Age 13*
91.59.34

Age 13, a three-color lithograph, was printed at the Des-
jobert Studios, Paris. Schreiber also made a black-and-
white lithograph, a watercolor, and an oil painting of the
same subject. It is the only work of art he created on a
Jewish theme and is a composite statement of his bar
mitzvah in Brussels.

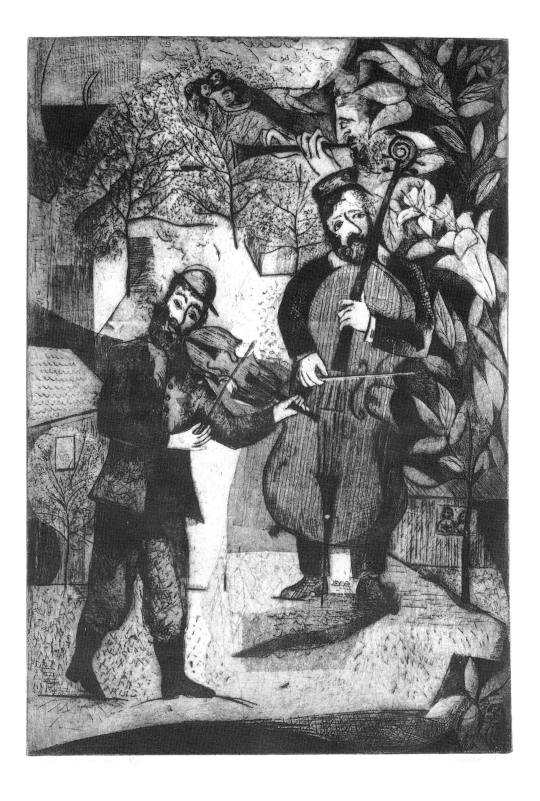

MOISHE SMITH

b. 1929

Printmaker. Born in Chicago. Studied at Carnegie Institute of Technology; Wayne State University; B.A., New School for Social Research, New York; M.F.A. and M.A., University of Iowa, where he worked with Mauricio Lasansky; Skowhegan School of Painting and Sculpture; Accademia of Florence; and with Giorgio Morandi in Bologna. Taught at Southern Illinois University, University of Wisconsin-Madison, and University of Wisconsin-Paskoid. Awarded a Fulbright Fellowship for study in Italy, 1959–61. Won many awards, including two Purchase Awards from the Library of Congress and an Achenbach Foundation for Graphic Arts Award. Work included in the permanent collections of many major museums, including The Fine Arts Museums of San Francisco; The Oakland Museum; Museum of Fine Arts, Boston; and The Museum of Modern Art, New York.

Yidl with His Fiddle, 1954
Etching on ivory
wove paper, 23/35
76 × 50 cm (27¾ × 19⅝ in.)
Signed and dated lower right:
Moishe '54; inscribed lower left:
Yidl With His Fiddle
91.59.9

A mythical musician heralds the klezmer, whom Smith places in the center of a magical setting of flying figures and finely delineated flora.

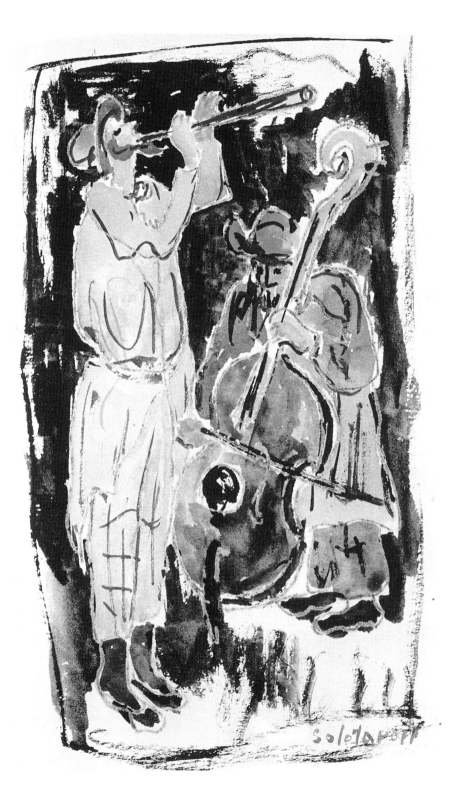

MOI SOLOTAROFF

1895–1970

Painter, stage-set designer. Born in Chigirin, Ukraine. To the United States, 1913. Studied at Art Students League; Cooper Union, both New York; Académie Colarossi, Paris, 1922. With his set designs, made an important contribution to Yiddish theater in America. Inspiration for his work came from the theater and the masters of Yiddish literature, such as Mendele Mocher Sephorim, I. L. Peretz, and Sholom Aleichem.

Untitled
(Two Musicians), ca. 1937
Watercolor on ivory wove paper
22.4 × 15.3 cm (8¾ × 6 in.)
Signed lower right: *Solotaroff*
91.59.21

Solotaroff designed most of the sets for the Artef Yiddish Theatre, which flourished in New York during the 1930s. This watercolor is a design for *The Outlaw* by the Yiddish dramatist Moishe Kulbach, directed by Benno Schneider. The musician depicted at left resembles the actor David Opatoshu, son of the Yiddish author Joseph Opatoshu.

David S. Lifson, in his book *The Yiddish Theatre in America* (New York and London: Thomas Yoseloff, 1965), discusses Solotaroff's work: "Working with Benno Schneider he helped achieve a balance, in set design and costume, between the abstract and the real. He used simple media of only wood and canvas, but his sets were effective in creating the specific mood and atmosphere demanded by a play" (p. 454).

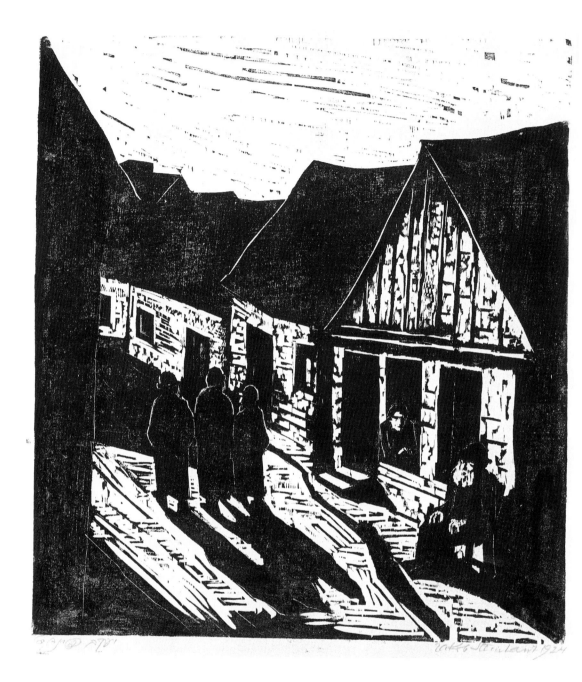

JAKOB STEINHARDT

1887–1968

Painter, graphic artist, teacher, book illustrator,* theater-set and costume designer. Born in Zerkow, in German-occupied Poland. Studied with painter Lovis Corinth and etcher Hermann Struck, Berlin; with Henri Laurens, Théophile Steinlen, and Henri Matisse, Paris. Founded expressionist group, Die Pathetiker, with Ludwig Meidner and Richard Janthur, 1912. Illustrated many books, including *Parables* and *Musical Tales* by I. L. Peretz, 1920. To Israel, 1933. Headed graphic department, Bezalel Academy of Arts and Design, 1949; director, Bezalel Academy, 1953–57.

Untitled
(The Shtetl), 1924
Woodcut on ivory wove paper
42.2 × 35.2 cm (16⅝ × 13⅞ in.)
Signed and dated lower right:
Jacob Steinhardt 1924; signed in
Hebrew lower left
91.59.23

While serving in the German Army during World War I in Lithuania, Steinhardt was deeply moved by experiencing orthodox Judaism for the first time. He made many prints depicting Jewish life in the German expressionist style he had developed earlier in Berlin. Here he achieves a sense of drama by leading us diagonally into the shtetl, following the elongated shadows of the villagers.

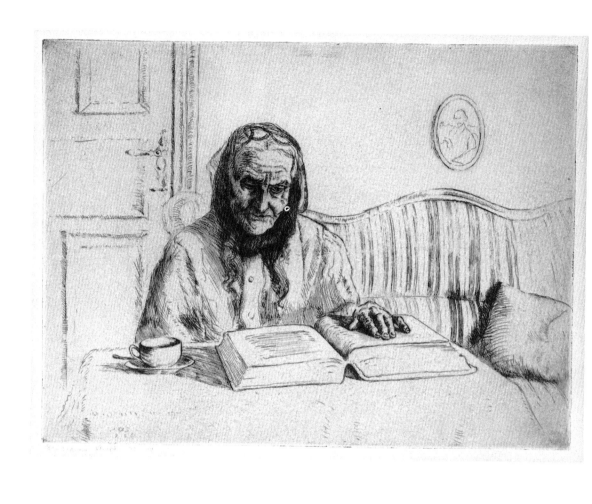

HERMANN STRUCK

1876–1944

Painter, graphic artist, book illustrator,* teacher. Born in Germany. Attended Gymnasium and Berlin Academy of Fine Arts. Studied with Jozef Israels in Holland and at the engraving studio of Hans Meyer, Berlin Academy. Taught and influenced many Jewish graphic artists. Elected member of Royal Society of Painters and Etchers, London, 1904. Published *The Art of Etching*, 1908. Member Berlin Secession. To Israel, 1923. Published many portfolios of his etchings and lithographs, including those depicting Russian and East European shtetl Jews (see Helzel, *Narrative Imagery*, pp. 17–23, 33–37).

Struck is renowned for his portraits of prominent personalities such as Albert Einstein and Theodore Herzl. He is also known for hundreds of portraits of unidentified figures that reflect great sensitivity and strength.

Grandmother II, 1928
Etching on buff laid paper,
47/100
26.7 × 38.5 cm (10½ × 15⅛ in.)
Signed lower left:
Hermann Struck; inscribed and
dated in plate lower left:
Star of David, *S, 28*
91.59.25

Untitled
(Man with Pipe), 1922
Etching on buff laid paper,
103/150
35 × 27.3 cm (13¾ × 10¾ in.)
Signed lower left:
Hermann Struck; inscribed and
dated in plate lower left:
H, Star of David, *S, 1922*
91.59.26

Struck witnessed Eastern European shtetl life during World War I when he served as a translator for the German Army. While at the eastern front he made hundreds of sketches, which were later made into etchings and lithographs and published in portfolios. His art of this period is an important document of East European Jewry.

Untitled
(Merchant)
Lithograph on ivory
wove paper, 15/25
21.7 × 28.2 cm (8½ × 11⅛ in.)
Signed lower left: *Struck*
91.59.27

In the shtetl, it was considered "better to work for oneself than for someone else, . . . independent merchants and businessmen are considered fortunate" (Zborowski and Herzog, *Life Is with People*, p. 247).

HENRI TOULOUSE-LAUTREC

1864–1901

Painter, graphic artist. Born in southern France. Studied in Paris under painters René Princeteau and Léon Bonnat, 1881–82. Received first commission while working with Fernand Cormon, to illustrate Victor Hugo's *La Légende des siècles*. Became an overnight success with his first lithographic poster, *Moulin Rouge—La Goulue*. Followed an independent path and developed a unique graphic style, making an inspired fine art of poster design and lithography. Subjects were drawn mainly from the circus, cabarets, theaters, and brothels of fin-de-siècle Paris. Produced an album of ten lithographs illustrating ghetto life in Poland, 1898.

La Prière des juifs polonais (The Prayer of the Polish Jews), 1898, 6/300
Lithograph on *chine volant* paper
33.3 × 22.9 cm (13⅛ × 9 in.)
Initialed in plate lower right: *TL*
91.59.28

This is one of ten lithographs Toulouse-Lautrec made to illustrate ghetto life in Poland for the album *Au pied de Sinai* (At the Foot of Sinai, published by Henri Floury, Paris, in 1898, with an introductory text by Georges Clemenceau). Individual impressions such as this one from *Au pied de Sinai* were also published by Henri Floury in 1898. Lautrec gained insight into his subject by observing and sketching poor Russian and Polish Jews in the Tournelle quarter of Paris.

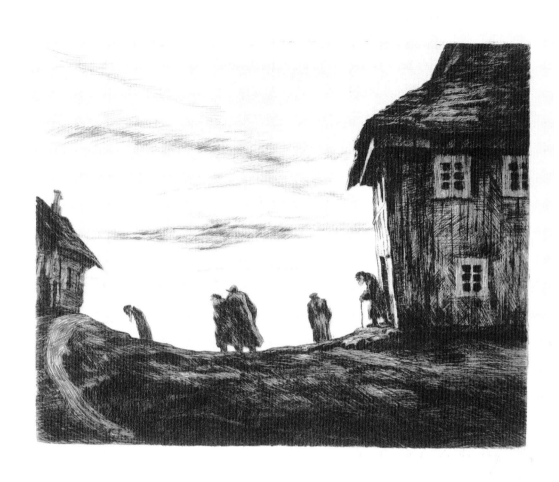

JULIUS C. TURNER

1881–1948

Painter, etcher. Born in Schivelbein, West Prussia. Studied at Academy for Fine Art, Berlin, with Woldemar Friedrich and Hans Meyer. Traveled in Holland and France. Immigrated to Belgium, 1936. Work mainly depicts industrial motifs and cityscapes; also did portraits of theatrical figures, early 1920s. Memorial exhibition of graphics, Munich, 1961. Several prints included in the permanent collections of the Judah Magnes Museum and The Fine Arts Museums of San Francisco.

Day after Day
Etching on buff wove paper
32.7 × 44.5 cm (12⅞ × 17½ in.)
Signed lower right:
Julius C. Turner
91.59.29

These elderly men are shown in their daily ritual—leaving a typical wooden synagogue of the shtetl after prayers. Turner's etching was included in the portfolio *DAVKA: Thirty Years after the World Vanished*, 1973. This portfolio of print reproductions, edited by Mark Hurvitz, was published to commemorate the thirtieth anniversary of the Warsaw Ghetto Uprising.

MIKHAIL TUROVSKY

b. 1933

Painter, illustrator. Born in Kiev, USSR. B.F.A., Kiev Art Institute; M.A. in graphic art, 1954–60; Ph.D., USSR Academy of Art, 1965–67. Illustrated over 120 books, including those by Walt Whitman, J. D. Salinger, and Pablo Neruda. Instructed art college students in drawing and composition, 1964–75. Directed own art school and instructed gifted students in painting and drawing, 1970–74. Member USSR Union of Artists, 1963–78. Expelled from the Union of Artists when applied for emigration, 1978. To New York, 1979. Published *Itch of Wisdom*, an anti-Soviet collection of aphorisms, 1990.

Untitled
(The Weavers), 1980
Charcoal on ivory wove paper
20.3 × 24 cm (8 × 9½ in.)
Signed and dated lower right:
M. Turovsky 1980
91.59.30

Turovsky was a prominent artist in Moscow, where he painted Leonid Brezhnev's portrait and held solo exhibitions in 1975 and 1976. He adhered to the state-controlled academic subjects of history painting, the Red Army, and portraits of Soviet heros. Frustrated at not being allowed to work freely, he emigrated. In the United States he devoted ten years to painting scenes of the Holocaust. He has also completed many drawings, watercolors, and paintings on the subject of shtetl life.

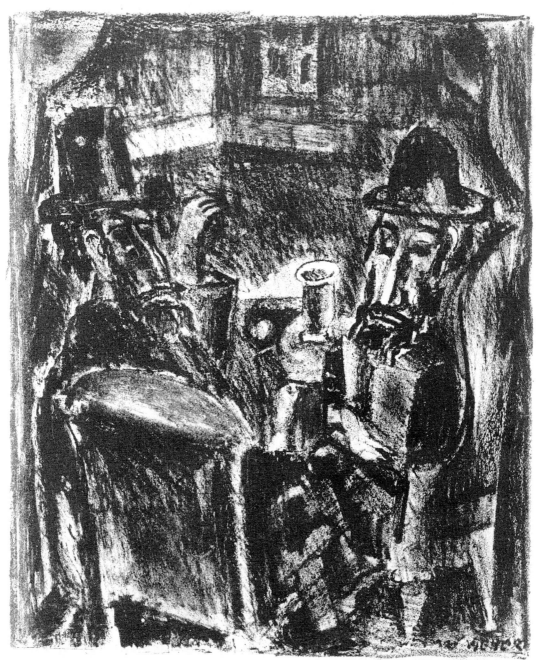

MAX WEBER

MAX WEBER

1881–1961

Painter, printmaker, teacher, author. Born in Białystok, Poland. To the United States, 1891. Studied at Pratt Institute, New York; Académie Julian, Académie de la Grande Chaumière, and Académie Colarossi, Paris. Taught at Art Students League, New York, through 1920s. Member of Stieglitz circle. By 1919 religious themes appear frequently in work. Involved with Yiddish poets' group, Di Yunge; published poems, woodcuts, and three essays in *Shriftn*, 1919–25. Elected national chairman of American Artists' Congress, 1937; worked on the art committee of the World Congress for Jewish Culture.

Sabbath, 1928
Lithograph on ivory wove
paper, edition of 30
27.5 × 18.8 cm (10⅞ × 7⅜ in.)
Signed lower right and in plate
lower right: *Max Weber*
91.57.51

This print relates to Weber's painting *Sabbath*, 1919 (Daryl R. Rubenstein, *Max Weber: A Catalogue Raisonné of His Graphic Work* [Chicago: The University of Chicago Press, 1980], p. 143). It was one of his first paintings on a Jewish theme. Weber's inspiration stems from the recollection of the Hasidim of his youth. In many works he recalls their customs and ceremonies of the home and synagogue.

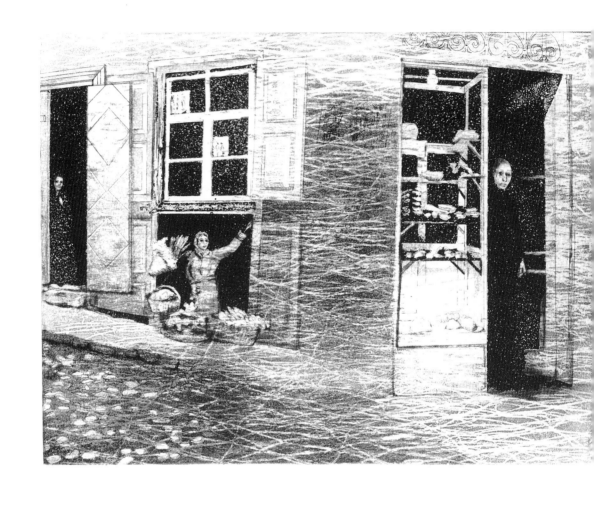

RUTH WEISBERG

b. 1942

Printmaker, teacher, writer, lecturer. Born in the United States. Studied at Junior School, Art Institute of Chicago, 1948–58; in Italy, 1960; received Laurea in painting and printmaking from Accademia de Belle Arti di Perugia. B.A. and M.A., University of Michigan; studied one year at S. W. Hayter's Atelier 17, Paris. Awarded a Ford Foundation Grant, 1969. Professor, University of Southern California, 1981. Author of numerous essays and articles; illustrator of the books *Tom O' Bedlam's Song*, 1969, and *The Shtetl, a Journal and a Memorial*, 1971.

Doors and Windows, 1971
Color etching on ivory
wove paper, 55/55
42.5 × 52.2 cm (16¾ × 20½ in.)
Signed and dated lower right:
Ruth Weisberg 1971;
inscribed lower center:
Doors and Windows
91.59.31

Doors and Windows is the fifth print in Weisberg's book *The Shtetl, a Journey and a Memorial*. The book is a memorial to her relatives who were lost in the Holocaust. The imagery recalls a photograph by the famed photographer Roman Vishniac, *108: Basement Storefront. Vilna, 1937*. Between 1934 and 1939 Vishniac took thousands of photographs of East European Jewish life, preserving this destroyed world for posterity. (See Bibliography for full citation of Vishniac's book.)

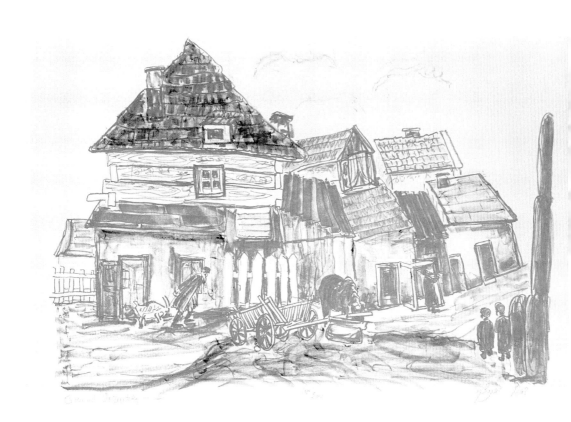

SAMUEL WODNITSKY

1895–1980

Painter, lithographer. Born in Kazimierz, Poland. Studied at art academy, Warsaw. Member of Association of Jewish Painters in Warsaw; honorary member in Cracow. To Israel, 1934. Awarded Dizengoff Prize, 1942. Concentrated on shtetl subjects. Exhibition on the shtetl, Yad Vashem, 1965. Work included in an exhibition of naive Israeli painters, Tel Aviv Museum of Art, Beit Dizengoff, 1970.

Milkman in Kuzmir
Hand-colored lithograph on ivory wove paper, 110/200
40.8 × 54.2 cm (16 × 21⅜ in.)
Signed lower left: *Samuel Wodnitsky*; signed in Hebrew lower right
91.59.32

Wodnitsky's iconography was focused totally on the people and occupations of his shtetl, Kazimierz on the Vistula. Here he illustrates a milkman; sometimes they raised their cows, producing their own supply, while others bought milk from farms and only delivered it to the villagers.

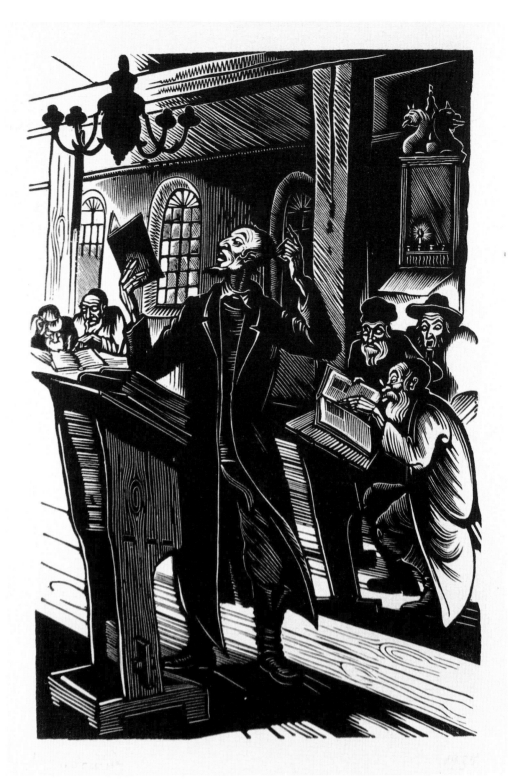

SOLOMON BORISOVICH YUDOVIN

1892–1954

Painter, draftsman, printmaker, book illustrator, teacher. Born in Beshenkovichi shtetl, district of Vitebsk, Russia. Studied with Yehuda Pen in Vitebsk, 1906; at School of the Society for Encouragement of Art, St. Petersburg, 1910; with M. Bernstein and M. Dobushinsky, 1911–13; and at Vitebsk Art Institute, 1919–22. Participated as a photographer in an ethnographic expedition to parts of the Pale, organized by the Jewish Historical and Ethnographic Society in St. Petersburg, led by S. An-Sky, 1912–14. Work includes many series based on Jewish life and contemporary experience. Published *Jewish Folk Ornaments*, twenty-six linocuts, 1920.

Untitled (Maggid), 1934
Wood engraving on ivory laid paper
19.8 × 14.5 cm (7¾ × 5¾ in.)
Signed lower left: *S. Yudovin*;
dated lower right: *1934*
91.59.33

From 1912 to 1914 Yudovin was part of the An-Sky ethnographic expedition in Ukraine collecting folk-art objects, legends, and histories. When Yudovin moved to Leningrad in 1923, he perfected his wood-engraving technique. In the 1930s he turned to social realism for themes but concurrently produced prints with traditional Jewish themes. Here Yudovin depicts a maggid (teacher-preacher) orating while his listeners study and pray.

BIBLIOGRAPHY

Glenn, Susan A. *Daughters of the Shtetl*. Ithaca, N.Y.: Cornell University Press, 1990.

Helzel, Florence B. *Narrative Imagery: Artists' Portfolios*. Exh. cat. Berkeley, Calif.: Judah L. Magnes Museum, 1991.

Levy, Jane, and Florence B. Helzel. *The Jewish Illustrated Book*. Exh. cat. Berkeley, Calif.: Judah L. Magnes Museum, 1986.

Roskies, Diane K., and David G. Roskies. *The Shtetl Book*. 2d ed. N.p.: Ktav Publishing House, Inc., 1979.

Schwarz, Karl. *Jewish Artists of the Nineteenth and Twentieth Centuries*. New York: Philosophical Library, 1949.

Vishniac, Roman. *A Vanished World*. New York: Farrar, Straus, and Giroux, 1984.

Zborowski, Marc, and Elizabeth Herzog. *Life Is with People: The Culture of the Shtetl*. New York: Schocken Books, 1952.

INDEX OF ARTISTS

THE JUDAH L. MAGNES MUSEUM *collects, preserves, and exhibits artistic, historical, and literary materials illustrating Jewish life and cultural contributions throughout history. The Museum is a major archive for historical documents of Jewry of the western United States and assists in the preservation of Jewish cemeteries of the Gold Rush era. Established in 1962, the Magnes became the first Jewish museum in the United States to be accredited by the American Association of Museums.*

MUSEUM BOARD OF TRUSTEES

Jacques Reutlinger,
 President Emeritus
Howard Fine,
 President
Harry Blumenthal,
 Vice President
Adele Hayutin,
 Vice President
Florence B. Helzel,
 Vice President
Gary J. Shapiro,
 Treasurer
Raine Rude,
 Recording Secretary
Seymour Fromer,
 Corporate Secretary

Lynne Baer
William Brinner
Norman Coliver
Edwin M. Epstein
Walter Frank
Marc Freed
Marianne Friedman
Martin S. Gans
David Golner
Frances Green
Frances Greenberg
Kurt Gronowski
Stanley R. Harris
Suzy Locke
Joan Mann

Peggy Myers
Jeremy Potash
John Reilly
Phyllis Rosenberg
Alan Silver
Alan J. Sternberg
Felix Warburg
Harry Weininger
Marvin Weinreb
Fred Weiss
Lottie Kornfeld,
 Ex Officio
Sue Warburg,
 Ex Officio

MUSEUM STAFF

Seymour Fromer, *Director*
Ruth Eis, *Curator, Special Projects*
Florence B. Helzel, *Curator, Prints and Drawings*
Sheila B. Braufman, *Curator, Painting and Sculpture*
Bill Chayes, *Curator, Film/Video and Photography, and Exhibits Designer*
Jane Levy, *Librarian, Blumenthal Rare Book and Manuscript Library*
Marni Welch, *Registrar*
Valerie Diane Huaco, *Assistant Registrar*
Paula Friedman, *Public Relations Director and Executive Secretary*
Lisbeth Schwab, *Director of Development*
Shoshana Bradley, *Membership and Tour Coordinator*
Mel Wacks, *Director, Jewish-American Hall of Fame*
Dr. Moses Rischin, *Director, Western Jewish History Center*
Ruth Kelson Rafael, *Head Archivist/Librarian, Western Jewish History Center*
Tova Gazit, *Associate Archivist/Librarian, Western Jewish History Center*
Susan Smith Morris, *Assistant Archivist, Western Jewish History Center*
Dr. Ava F. Kahn, *Research Associate, Western Jewish History Center*
Laura O'Hara, *Photo Archivist, Western Jewish History Center*
Brad Berman, *Traveling Exhibits Coordinator*
Arléne Sarver, *Director, Order Department and Museum Shop*
Dan Shiner, *Accountant*
Natanya Groten, *Research Assistant*